IMAGES
of America

CHARLES TOWN

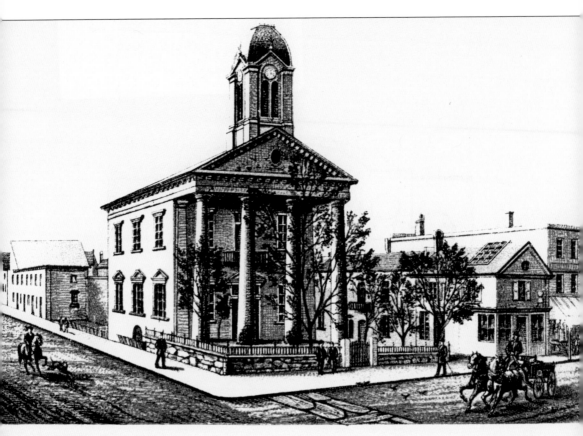

JEFFERSON COUNTY COURT HOUSE, WHERE JOHN BROWN WAS TRIED AND SENTENCED, CHARLESTOWN, W.V.

CHARLES TOWN COURTHOUSE. This *c.* 1880 drawing shows the courthouse and other buildings located on the northeast corner of East Washington and North George Streets, one of the four lots set aside by the town's founder Charles Washington to be used for community purposes. Men amble along and ride horseback down North George Street, as a horse and carriage approaches on East Washington Street. Today, the courthouse still serves the public, although it has been many years since it has seen such dramatic trials as those of John Brown and his raiders in 1859 or the Miners' Trial in 1922. (Courtesy of the Historic Photograph Collection, Harpers Ferry National Historical Park.)

IMAGES
of America

CHARLES TOWN

Dolly Nasby

ARCADIA
PUBLISHING

Published by Arcadia Publishing
Charleston SC, Chicago IL, Portsmouth NH, San Francisco CA

Printed in the United States of America

Library of Congress Catalog Card Number: 2004108737

For all general information contact Arcadia Publishing at:
Telephone 843-853-2070
Fax 843-853-0044
E-mail sales@arcadiapublishing.com
For customer service and orders:
Toll-Free 1-888-313-2665

Visit us on the Internet at www.arcadiapublishing.com

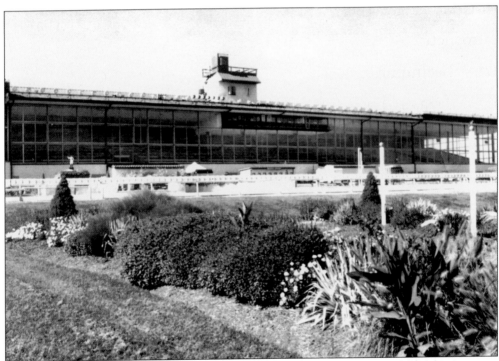

CHARLES TOWN RACE TRACK. Starting out with races run down the middle of the main thoroughfare—with even George Washington's horses participating—horse racing has evolved over the years. At one point there were two racetracks as well as a Colored Horse Association. Today people come not only for the horse races and the pari-mutuel betting, but also for the 3,500 slots available for gaming. (Courtesy of Charles Town Races and Slots.)

CONTENTS

ACKNOWLEDGMENTS

When anyone embarks on an endeavor such as this, it behooves her to be humble and thankful for all the help she receives. I never could have done this project without the help of many people. First, thanks to Arcadia for giving me the contract to complete this project. Also, a big thank you to Nancy Hatcher of the Harpers Ferry National Historical Park, who helped me identify the photos for the chapter on the treason trials. She was also very instrumental in my first book, *Harpers Ferry*. Next, a huge thank you goes to Bill Theriault of Bakerton, West Virginia. He has a tremendous collection of photos, and he scanned many for me to use in this book. Another very helpful person was prominent Charles Town citizen James Taylor, a graduate of, and former teacher at, Page-Jackson High School. Mr. Taylor was incredibly helpful in getting photos of the African-American community. A big thank you also goes to Katharine Crane and Susan Collins of the Jefferson County Museum in Charles Town for letting me scan some of the photos from their collection.

One of my biggest regrets with this book is that I could not include more photos—there are so many wonderful ones I could not include in this volume because of lack of space. For historical experts out there reading my book and looking for errors, I apologize, but you will probably find some. I do make mistakes, and I apologize for any I have made in this book. If you find any, please notify Arcadia and cite your sources so we can make corrections.

The history of Charles Town that I present in this book is by no means complete. I tried to get photos that illustrated the story of Charles Town, but that was not always possible. If there were some important facts I felt could not be omitted but did not have a photo for, I tried to include that information in captions where I could fit them. I hope the reader looks at my bibliography and takes the initiative to do some further reading about Charles Town and Jefferson County. It is a fascinating little town that has come through good times and bad, continuing to improve with age, like good wine.

An especially heartfelt thanks goes to my husband, who endured many evenings watching TV alone while I was click-click-clicking on my computer. I dedicate this book to him—without his love and support over the past 41+ years I never could have become the person I am today.

INTRODUCTION

A 16-year-old George Washington surveyed lands in the employ of Lord Fairfax in the mountains of present-day West Virginia, which was part of Virginia at the time. George fell in love with the beauty of the valley and purchased land. His brother Lawrence did the same, and when Lawrence passed away he left his holdings to their youngest brother, Charles Washington, after whom the town was named. Washington descendants continue to reside in Charles Town to this day.

Each chapter in the book has a central theme; Chapter One introduces Charles Town and discusses its beginnings. Charles Town was established by an act of the Virginia General Assembly in January 1787. The town was originally called Charlestown; the name would later be changed to Charles Town.

Chapter Two deals with the treason trials that were held in Charles Town. As the site of two of the three treason trials held in the United States, Charles Town became a household name. In 1859, seven raiders, including John Brown and two African Americans were tried and convicted of treason. In 1922, the Miners' Trials were moved to the Charles Town Courthouse in Jefferson County from Logan County.

The racetracks are covered in Chapter Three. The love that Charles Town has for horse racing goes back to its old days as part of Virginia. Local citizens would race their horses down the main thoroughfare to prove who had the fastest steed. Those races would eventually evolve into a much more sophisticated form of racing with race tracks, horse trainers, horse stewards, exercise boys, veterinarians, and even betting. Later, not only could visitors bet on the horses, but they could also gamble in the casino using a wide variety of slots.

Throughout the 19th century, private racetracks were in operation. The first show of the Charles Town Horse and Colt Show Association took place on Thornton T. Perry's farm on August 7, 1913. A crowd of 4,000 attended the event. Three months later, that first organization would be reorganized and become Charles Town Horse Show Association. For 50 years thereafter, visitors came to the county for horse races and shows. Because of segregation, African Americans had their own horse association, the Colored Horse Association, which was chartered on May 3, 1921, and survived for several years. In 1933, the state legislature legalized horse racing and pari-mutuel betting. The Charles Town Race Track opened in 1933 with 22 buildings, including 12 stables, 44 betting windows, 3,000 seats in the grandstand, and a clubhouse. Financially, the track did not do well the first few years, but race fans would not give up. Even though the racetrack went into receivership, Albert J. Boyle convinced backers that

it would become profitable by enticing betters from Baltimore and Washington involved. After much deliberation by the citizens, another track was constructed, opening in 1957. Shenandoah Downs gave spectators a different form of racing to enjoy—harness racing. As the two race tracks competed for spectators, the Downs had a distinct advantage because it offered night racing; the Charles Town Race Track also participated in night racing after installing lights in 1964, adding almost 60 racing days. Eventually Shenandoah Downs closed, leaving only the Charles Town Race Track, later called Charles Town Races & Slots.

The daily lives of people in Charles Town are portrayed in Chapter Four. Chapter Five deals with education, of both white children and black. Not all schools were covered, because of the lack of photos. All schools were segregated until the late 1950s or early 1960s, as the photos will show.

Military service is covered in Chapter Six. As Americans, we can never repay our servicemen and women for their contributions. Various branches of the service are represented in this chapter, although not all of them are covered because of lack of photos.

Chapter Seven deals with important buildings, organizations, and people. Over time, Charles Town has changed greatly, and probably in no area more so than transportation and communication—Chapter Eight deals with those topics. Throughout Charles Town and the surrounding hamlets, music has been a key element in society. Chapter Nine deals with organized musical groups, all of which were segregated, as the photos show. It would not be until the late 1950s and 1960s that any musical groups would become integrated.

Chapter Ten shows the reader what the town looks like today. For all of her past glory, Charles Town continues to thrive. A walk down Washington Street, the main thoroughfare, reminds you of days gone by. The buildings have kept their original façades, the concrete sidewalks have been replaced with red bricks, and the four lots in the center of town look very much as they did during the 1800s, with the exception of traffic lights and modern vehicles. Charles Town, for all of its change, has remained much the same.

And what does the future hold for Charles Town? The history is being preserved by several societies all bent on saving the past while we enjoy the present. Take a step back in time, glance at the photos, read the captions, and catch a glimpse of what life was like in Charles Town in days gone by. And if you feel so moved, glance at the bibliography and become better acquainted with the history of Charles Town.

One

BEGINNINGS

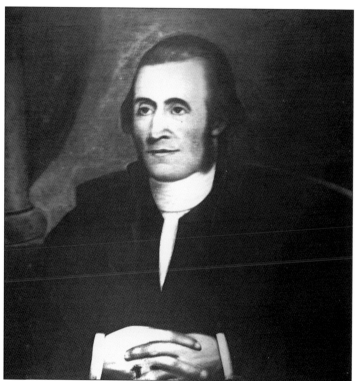

CHARLES WASHINGTON. Charles Washington, youngest brother of President George Washington, founded Charles Town. He grew up in Fairfax County, Virginia, and moved to the Charles Town area between April 20 and October 6, 1780, after he inherited land from his half-brother Lawrence Washington, who had died in 1752. Charles Town was established on 80 acres laid out by Charles. Both Charles and George Washington died in 1799. (Courtesy collection of Bill Theriault, Bakerton, WV.)

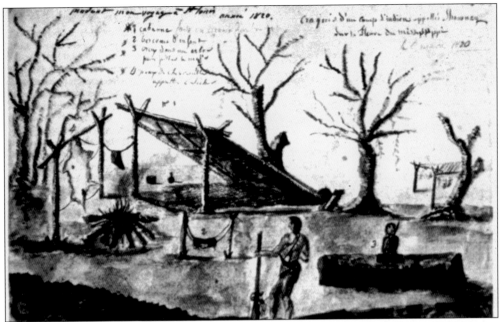

NATIVE-AMERICAN CAMP. Native Americans were present in the area back to c. 11,000 B.C., and their influence is reflected in the names of local rivers—Shenandoah means "Daughter of the Stars" and Potomac means "River of Wild Geese." This sketch depicts how a Native-American camp might have appeared. A pole shelter is visible, an infant's cradle is constructed of cloth over two cords, and deer hides are stretched for drying. (Courtesy collection of Bill Theriault, Bakerton, WV.)

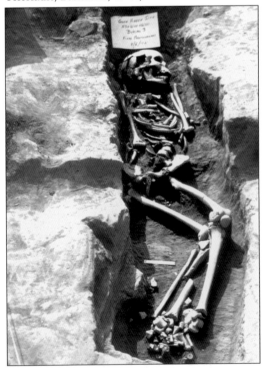

NATIVE-AMERICAN BURIAL. The skeleton of a Native American buried east of Bakerton can be seen in this photo. Several graves were unearthed in 1972 as part of the Glen Haven Indian excavation. The size of the grave required that the legs of the corpse be bent prior to burial, which was not true in all cases. Mound Builders, or Adena people, were the first native settlers of the eastern panhandle region of West Virginia. (Courtesy collection of Bill Theriault, Bakerton, WV.)

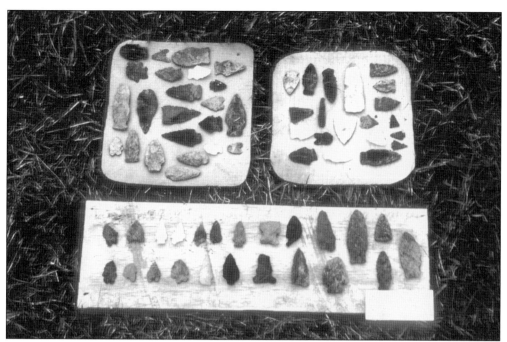

ARROWHEAD COLLECTION. The arrowheads displayed here are part of Robert Duke's collection from the Glen Haven Indian excavation of August 1972. The local Native Americans were nomadic hunter-gatherers. Settlers arrived after following the old Indian trails. This photo was taken by E.E. McDowell-Louden and Gary Louden. (Courtesy collection of Bill Theriault, Bakerton, WV.)

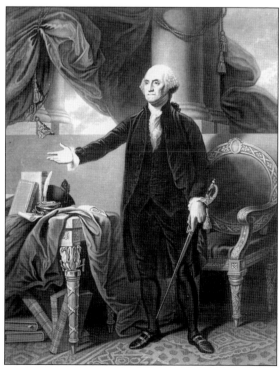

GEORGE WASHINGTON. When George Washington was 16 years old, he was a surveyor for George William Fairfax and James Genn. He was intrigued by the beauty of the Shenandoah Valley and saved his surveying fees to purchase Bullskin Plantation from Robert Rutherford in 1750. The manor house, Rion Hall, was destroyed by fire in 1906. George Washington presided as master of the first lodge of Free Masons west of the Blue Ridge Mountains.(Photo from *Portraits of the Presidents and First Ladies, 1789 Present*, Library of Congress, digital ID cph 3a10229.)

LAW OFFICE OF CHARLES WASHINGTON. Pictured here is the law office of Charles Washington. Located on North Lawrence Street between Liberty and Washington Streets, this small brick building was constructed during the last quarter of the 18th century. It was built to be used as an office. (Courtesy collection of Bill Theriault, Bakerton, WV.)

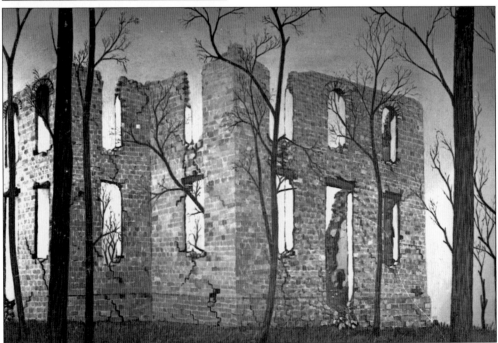

ST. GEORGE'S RUINS. St. George's Episcopal Chapel was the first church built west of the Blue Ridge Mountains. Many members of the Washington family worshiped here. The ruins are west of Charles Town on Route 51. The church, built *c.* 1769 by wealthy landowners, had been called one of the most beautiful small churches in the valley. Services were held here until 1811 or 1817, at which time the Charles Town Zion Episcopal Church was completed. (Courtesy collection of Bill Theriault, Bakerton, WV.)

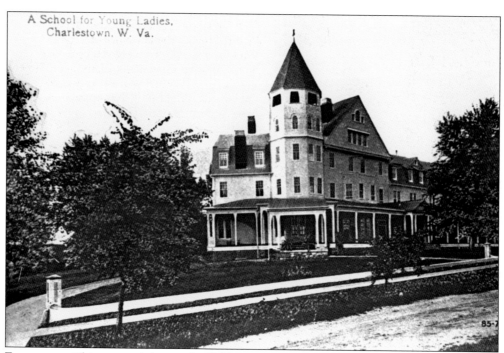

A School for Young Ladies,
Charlestown. W. Va.

EDUCATION. This postcard depicts St. Hilda's Hall, a school for young white ladies. Before St. Hilda's Hall was established, the Charles Town Academy for boys was begun, and it continued until 1905. It was a seminary of learning where Latin and Greek were taught. On April 23, 1846, free schools were approved. Indigent children from age 5 to 21 would be taught for free, and others would be charged up to 50¢ per quarter. (Courtesy collection of Bill Theriault, Bakerton, WV.)

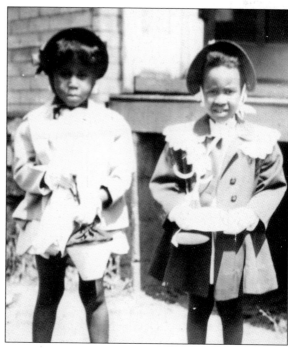

LITTLE GIRLS, POSSIBLY EASTER. These girls appear to be dressed in their Eastern finery. While white society took pictures of their family, friends, and activities quite frequently, photos of African Americans are more difficult to locate. Photos of African Americans appear throughout the book, which the author felt was more appropriate than devoting one chapter to their history. (Courtesy collection of James Taylor, Charles Town, WV.)

13

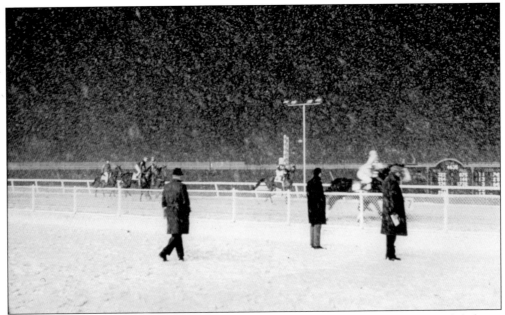

RACE TRACKS. Diehard race fans wait to watch a race in a very heavy snowstorm. While horse racing has changed drastically from the past, it has been a part of Charles Town history since 1786. The first horse show was held in 1914. The African-American community had a Charles Town Colored Horse Association, which began in 1921. Thoroughbred racing as we know it today began in 1933. (Courtesy collection of Bill Theriault, Bakerton, WV.)

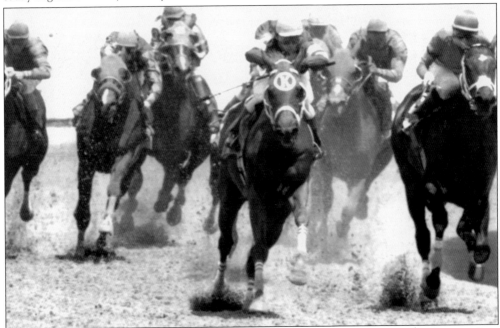

HORSES RACING. Coming down the home stretch, the jockeys and their steeds give their best. Crowds come for racing, pari-mutuel betting, and the slot machines. Charles Town Races & Slots has 3,500 slots, and the number grows every year. (Courtesy of Charles Town Races & Slots.)

Two

TREASON TRIALS

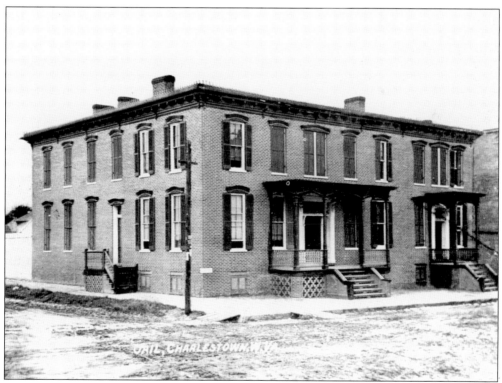

JAILHOUSE IN CHARLES TOWN. This 1900 photo shows the jailhouse where seven people who participated in the Harpers Ferry raid were held. They were all sentenced to hang for treason, conspiring slaves to rebel, and murder. Located on the corner of George and Washington Streets on one of the four lots set aside for community use, the jail was torn down in 1919 to make room for a new post office. (Courtesy of the Thomas Featherstonhaugh Collection, Library of Congress.)

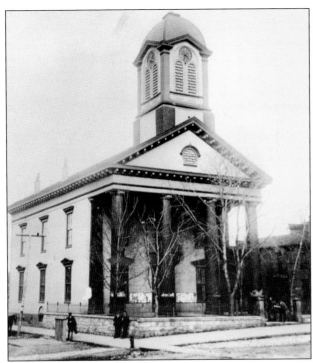

CHARLES TOWN COURTHOUSE. Built in 1801, this courthouse housed the trials of abolitionist John Brown and his raiders in 1859 and the Miners' Trials of 1922, two of the three treason trials in U.S. history. The courthouse was partially destroyed during the Civil War, after which only the walls remained, and the county seat was temporarily moved to Shepherdstown. After the courthouse was restored and enlarged, the county seat returned to Charles Town. The photograph is *c.* 1900. (Courtesy of the Thomas Featherstonhaugh Collection, Library of Congress.)

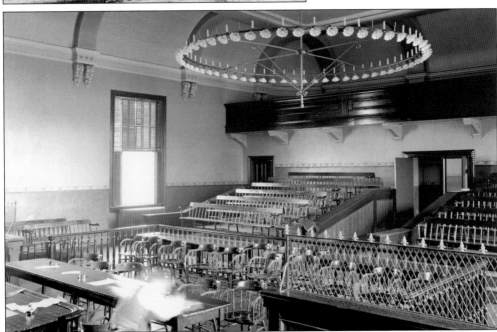

CHARLES TOWN COURTHOUSE, INTERIOR. During the Civil War, when county employees knew that Charles Town would be part of the Civil War battleground, County Clerk Thomas A. Moore supervised the loading of a wagon with all valuable papers and records and moved them 160 miles south to Lexington. That foresight saved much valuable history, which would have been lost otherwise. (Courtesy of the Library of Congress, HABS, WVA, 19-CHART, 3-11.)

JOHN BROWN. This photo was taken about 1859. Brown was captured October 18, 1859, brought to Charles Town, arraigned on October 25, and indicted for treason on October 26. He pleaded not guilty and was tried over three and a half days. Sentencing took place on November 2, 1859, and he was hanged on December 2, 1859, a Friday. Six other raiders were also hanged. (Courtesy of Library of Congress Prints and Photographs Division Washington, D.C.)

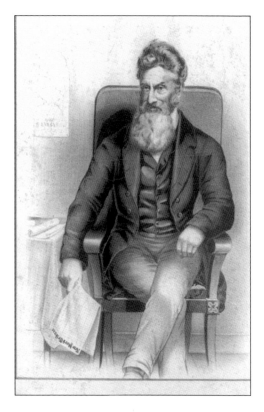

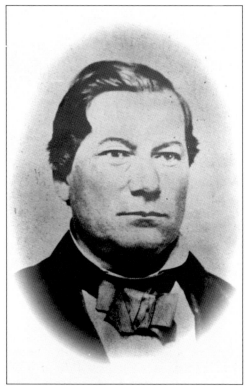

JOHN AVIS. Jailer John Avis was responsible for John Brown while in the Charles Town jail. Avis led the Jefferson Guards from Charles Town when they cut off Brown's escape routes and trapped him in an engine house. Brown gave Avis his silver watch in appreciation for the care he had received. Avis also served as mayor of Charles Town, superintendent of the county almshouse, and justice of the peace. (Courtesy of the Historic Photo Collection, Harpers Ferry National Historical Park.)

17

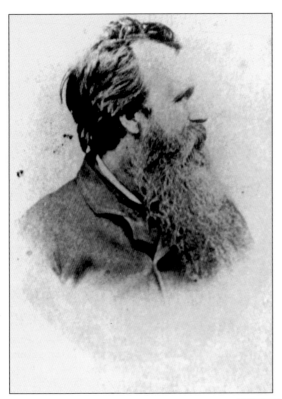

EDWARD BRACKETT. Edward Brackett went to Charles Town to make a cast of Brown's features prior to his execution. In the making of a mask, the face was covered with a layer of plaster that was removed when it had hardened. The original mask made by Brackett is located in Boston. A replica is in Hampton, Virginia. (Courtesy of Thomas Featherstonhaugh Collection, Library of Congress.)

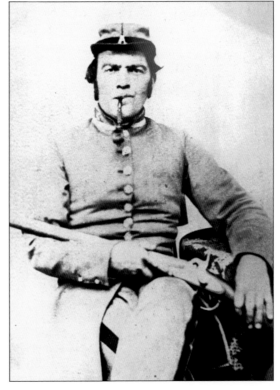

JOHN FREDERICK BLESSING. John Blessing provided meals for John Brown during his incarceration and trial, and Brown gave Blessing his Bible. Blessing ran a confectionary at the corner of Charles and Washington Streets during the Civil War. Because there had been rumors of a plot to help the raiders escape, Brown and his raiders were carefully watched prior to their trials and executions. This photograph was taken Edwin Fitzpatrick. (Courtesy collection of Bill Theriault, Bakerton, WV.)

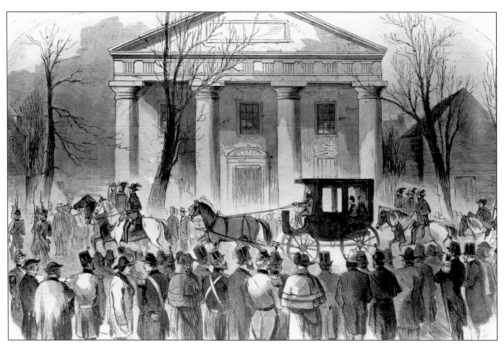

MRS. BROWN ARRIVES FOR TRIAL. Mrs. Mary A. Brown arrived in Charles Town with a military escort. On December 1, the Browns dined with John Avis. After Brown was hanged, his body was delivered to Mary at Harpers Ferry. It was shipped to Philadelphia, where it was placed in a Northern coffin; Brown could not be buried in a coffin made in the South. (Courtesy Mr. Boyd B. Stutler, Charleston, WV, published in *New York Illustrated News*, December 17, 1859.)

ANDREW HUNTER. Hunter, John Brown's prosecutor, wrote the indictment. The defendants were charged with treason against the commonwealth of Virginia, advising and conspiring slaves to rebel, first-degree murder of all victims collectively, and the murder of three citizens individually. During the Civil War, Hunter's house was burned by Union Gen. David Hunter, his first cousin; Andrew was imprisoned for a month, ironically wearing a ring David had given him as a sign of affection. (Courtesy of Thomas Featherstonhaugh Collection, Library of Congress.)

19

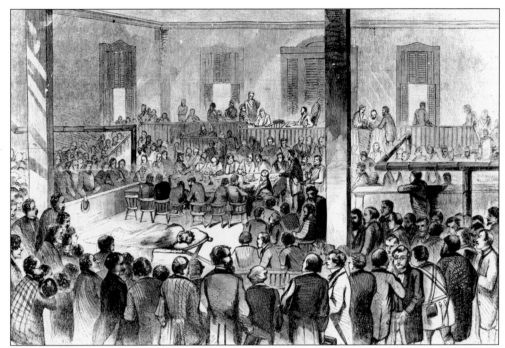

TRIAL OF JOHN BROWN. This sketch shows Brown in the Charles Town courtroom, reclining on a cot during his trial. He was injured by Lieutenant Green when the engine house was attacked. Green brought his sword down on Brown, cutting deep wounds in the back of Brown's neck and rendering him unconscious. When tried, Brown was still suffering from the wounds. Porte Crayon sketched the scene. (Courtesy of the Historic Photo Collection, Harpers Ferry Historical Park.)

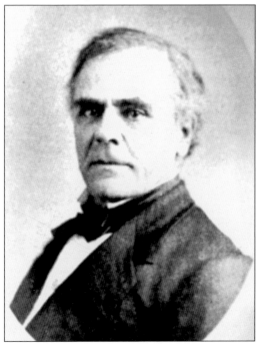

JUDGE RICHARD PARKER. Judge Parker of Winchester presided over John Brown's trial. Brown asked for a delay for health reasons; he was examined by a reputable Charles Town physician, Dr. Gerard F. Mason, and was declared able to stand trial. Brown requested a cot to lie on during the trial, and that request was approved. The cot is on display in the Jefferson County Museum in Charles Town. (Courtesy collection of Bill Theriault, Bakerton, WV.)

SHIELDS GREEN. "Emperor" Shields Green, an illiterate young fugitive slave from Charleston, South Carolina, was a protégé of Frederick Douglass. Douglass refused to participate in the raid, but Green went with Brown. Green was one of five African Americans involved in the raid, and one of two who were captured. He was executed on Saturday, December 17, 1859. His body was buried under the gallows and later exhumed. (Courtesy of the Historic Photo Collection, Harpers Ferry National Historical Park.)

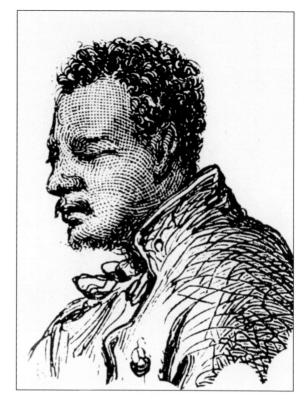

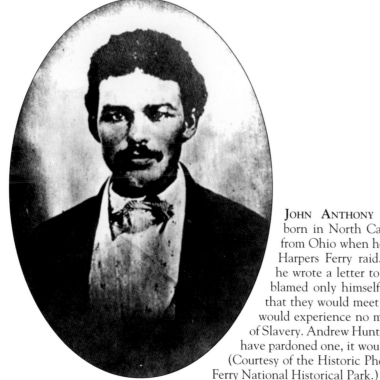

JOHN ANTHONY COPELAND. Copeland, born in North Carolina, was a freedman from Ohio when he was captured after the Harpers Ferry raid. Before his execution, he wrote a letter to his family in which he blamed only himself for his fate and stated that they would meet in Heaven, where they would experience no more the unjust monster of Slavery. Andrew Hunter stated that if he could have pardoned one, it would have been Copeland. (Courtesy of the Historic Photo Collection, Harpers Ferry National Historical Park.)

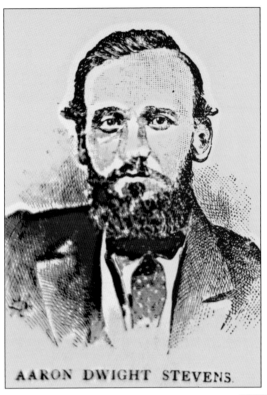

AARON DWIGHT STEVENS.

AARON DWIGHT STEVENS. Stevens was arrested and taken to Charles Town, where he was arraigned on October 25, 1859, and indicted for treason on October 26, 1859. Stevens had to be held up by two bailiffs because his wounds were so severe; he had been shot while carrying a flag of truce. Prior to his death, he stated that he was willing to die for the oppressed. (Courtesy of the Historic Photo Collection, Harpers Ferry National Historical Park.)

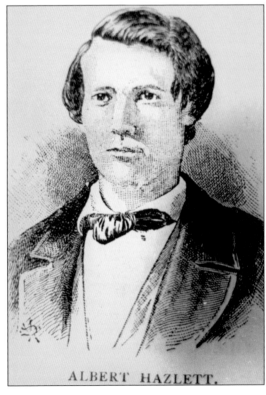

ALBERT HAZLETT.

ALBERT HAZLETT. Hazlett was from Pennsylvania and had been working on his brother's farm before the raid. He was caught in Pennsylvania and was extradited illegally to Virginia. On the night before he was executed, he wrote a letter from prison stating that he was willing to die in the cause of liberty. He was tried during the next term of the court in February 1860 and hanged on March 16, 1860. (Courtesy of the Historic Photo Collection, Harpers Ferry National Historical Park.)

EDWIN COPPOC. Coppoc, a Quaker, lived with his brother Barclay—a raider who escaped to Iowa—and his mother in Springdale. During the raid, Edwin killed the mayor of Harpers Ferry. He surrendered in the engine house. He insisted that he did not know of the plan to seize the arsenal. He was hanged on Friday, December 16, 1859. (Courtesy of the Historic Photo Collection, Harpers Ferry National Historical Park.)

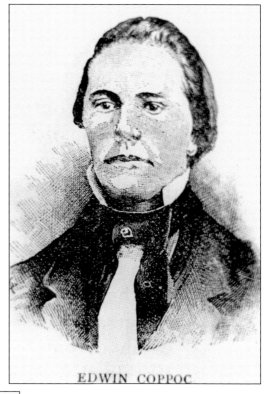

EDWIN COPPOC

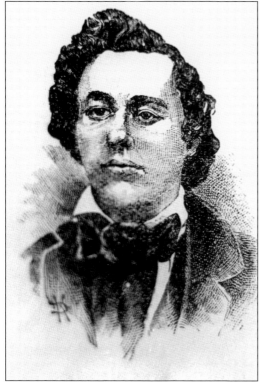

JOHN EDWIN COOK. Cook, from a wealthy Connecticut family, attended Yale and studied law in New York. He spent a year in Harpers Ferry learning about the armory and the arsenal. Brown sternly ordered Cook to keep quiet, since he tended to be verbose. He impregnated Mary Kennedy, whom he married in April 1859. Cook escaped but was captured near Chambersburg, Pennsylvania. On December 16, 1859, he was hanged. (Courtesy of the Historic Photo Collection, Harpers Ferry National Historical Park.)

23

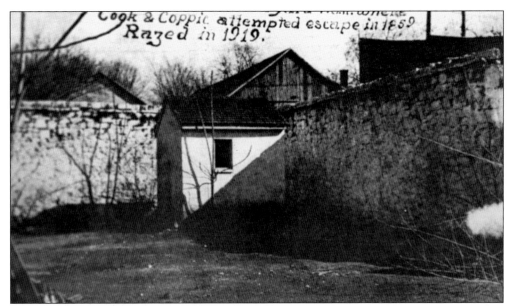

Cook & Coppic attempted escape in 1859 Razed in 1919.

OLD JAIL YARD. Cook had some relatives visit, and he did not want them to be implicated in his and Coppoc's escape plan, so they postponed it for one night. Since the attempt was postponed, friend and jailer Charles Lenhart was not on duty to help. While Avis was at supper, Cook and Coppoc dropped into the yard. When they mounted the jail wall, a sentinel fired at them. They dropped back into the yard and surrendered. (Courtesy collection of Bill Theriault, Bakerton, WV.)

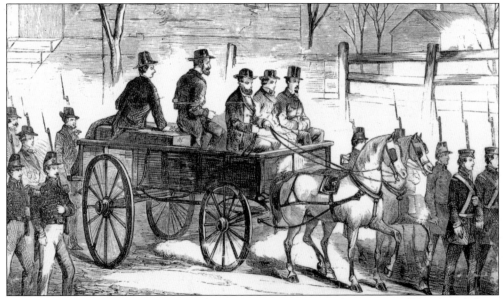

EN ROUTE TO HANGING. Brown rides to his execution on his own coffin. No civilians were allowed within a quarter-mile of the scaffolding, and the town was under martial law. Over 1,500 soldiers were in attendance as a safety precaution; one of them was John Wilkes Booth. The hanging took place at 11:30 a.m. on December 2, 1859. A simple stone marker memorializes the site of the hanging. (Courtesy of the Historic Photo Collection, Harpers Ferry Historical Park.)

JOHN WILKES BOOTH. John Wilkes Booth enlisted with the Richmond Grays on November 20, 1859, solely to witness the hanging of John Brown. Soon after the hanging, he left for Richmond, where he was discharged. John was 27 when he killed President Lincoln on April 14, 1865. Booth was killed on April 26, 1865. (Courtesy of National Park Service.)

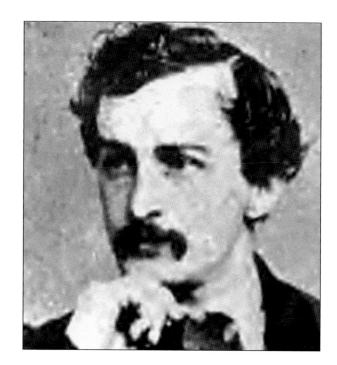

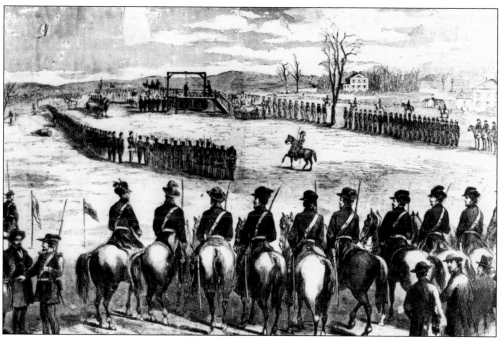

JOHN BROWN HANGING. This December 2, 1859 sketch shows the field with 1,500 troops in attendance commanded by Gen. Stonewall Jackson. In the upper right can be seen Happy Retreat, the home of Col. Charles Washington. At 11:15 a.m. Brown was hanged. His body was cut down, but his pulse did not stop until 35 minutes later. He was placed in a coffin and sent to Harpers Ferry. (Courtesy of Historic Photo Collection, Harpers Ferry National Historical Park.)

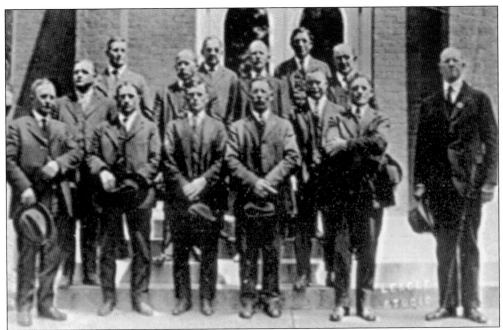

MINERS' TRIAL, 1922. This 1922 photo shows a jury from the Miners' Trial. Special deputy James Grantham is on the extreme right. The Miners' Trials were moved from Logan County to the courthouse in Charles Town. Coal officials, their lawyers, and witnesses, set up headquarters in the Hilltop House Hotel in Harpers Ferry, at the time the county's finest hotel. Even United Mine Workers president John L. Lewis attended. The men were not convicted of treason, but two were convicted of murder. (Courtesy of Bill Theriault, Bakerton, WV.)

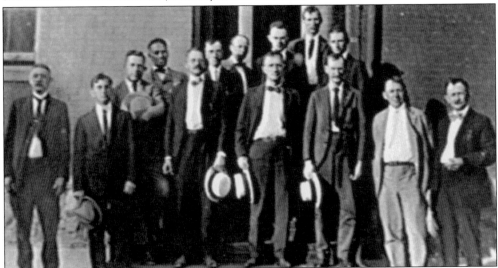

WALTER ALLEN JURY. Walter Allen, from Dry Branch, was convicted of treason and sentenced to 10 years as a result of the miners' rebellion. Fifteen thousand armed men marched in Logan and Mingo Counties to protest mine officials' opposition to unionizing. They were subjected to machine-gun fire, bombs dropped from planes, and three days of fighting, in which 24 men died. Almost 1,000 were charged with treason; about 800 were brought to Charles Town for trial. (Courtesy of Jefferson County Museum, Charles Town, WV.)

Three

RACE TRACKS

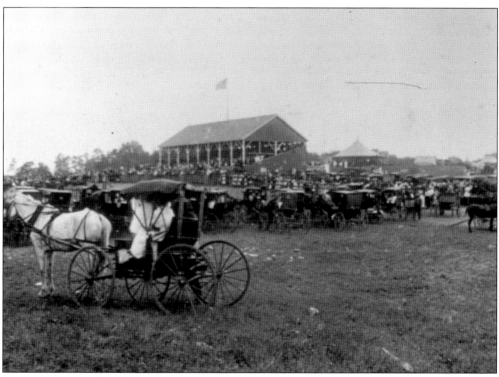

FIRST MEETING. This photo shows the first Charles Town Horse Show Association. Sponsored by Thornton T. Perry, the first meeting took place August 7, 1913. While no racing took place, the event was both a social and a financial success. It continued to have horse shows for the next 50 years. Horseracing as we know it today began in 1933. This photo was reprinted in the *Spirit of Jefferson–Advocate* on April 3, 1987. (Courtesy collection of Bill Theriault, Bakerton, WV.)

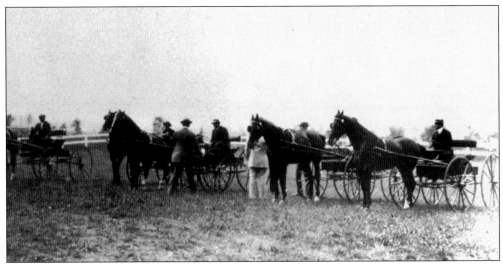

JUDGING CARRIAGE HORSES. In this photo, the carriages and horses are being judged. Although racing in Charles Town started as early as 1786, it was not until 1808 that the Charles Town Jockey Club began. Charles Town had the first horse racetrack in the state of West Virginia. Construction began in October 1933 and the track opened in December with much fanfare. (Courtesy of Jefferson County Museum, Charles Town, WV.)

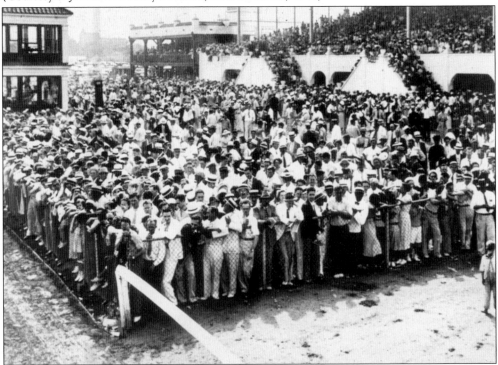

GRANDSTAND, 1933. This large crowd in the grandstand waits patiently for the action to begin. The edge of the roof of the judges' stand is visible to left. The love of horse racing in Jefferson County dates back to its Virginia heritage, both for a love of the sport and horses and for the love of competition. As a result of the introduction of night racing, people began to come as a form of entertainment. (Courtesy collection of Bill Theriault, Bakerton, WV.)

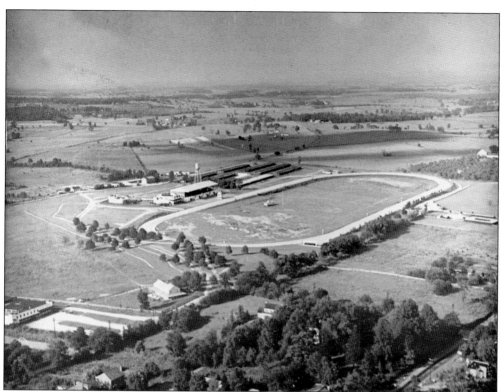

CHARLES TOWN RACE TRACK. This 1945 aerial view shows the Charles Town Race Track. Fifty years later, the same aerial shot would be very different. The press box at the Charles Town track was unusual because it hung out directly over the finish line. The design of the clubhouse itself was similar to the Spanish style of the Hialeah Track in Florida. Edwin Fitzpatrick took this photo. (Courtesy collection of Bill Theriault, Bakerton, WV.)

STARTING CREW. Pictured in this 1946 photo is the starting crew at Charles Town Race Track. Going up the ladder from left to right are John Morrisey, Harold Holland, Bob Duffy, Guy Owens, "Cowboy" Davis, and John Gore on the top step. The racetrack became a major employer in Jefferson County, with the local economy coming to depend on it for income. Edwin Fitzpatrick took this photo. (Courtesy collection of Bill Theriault, Bakerton, WV.)

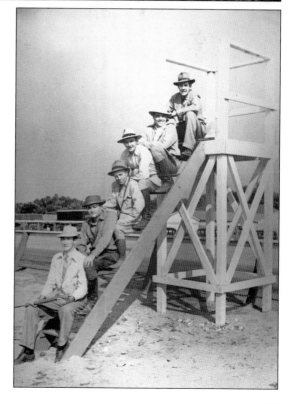

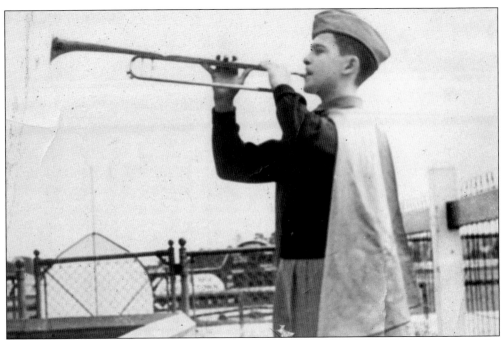

IT IS NOW POST TIME. In this early 1940s photo, Franklin E. Manuel blows the trumpet at the Charles Town Race Track. "It is now post time," preceded by the blowing of the trumpet, has always served as an announcement that the race is about to begin. Originally played by a real person before each race, the trumpet has now been replaced by a recording in many racetracks throughout the country. (Courtesy collection of Bill Theriault, Bakerton, WV.)

NATIONAL PRESS CONFERENCE. Here is a photo of a National Press Conference outing at the Charles Town Race Track in 1945. Pictured from left to right are Lee Hannify (UPE), Ben Backover (UPI), and Sam Thompson (*Philadelphia Enquirer*). UPI (United Press International) has become one of the largest worldwide news services. (Courtesy collection of Bill Theriault, Bakerton, WV.)

SNOWSTORM RACES. Diehard fans arrive at the racetrack in the middle of a snowstorm. One key to successful racing in Charles Town was winter racing, which no other track in West Virginia offered. When the West Virginia legislature approved a second track for Charles Town, the look of racing changed along with the clientele. The Charles Town Race Track had been the only track in town—that changed when Shenandoah Downs opened. (Courtesy collection of Bill Theriault, Bakerton, WV.)

TRACK VETERINARIAN. Dr. Trussell was the veterinarian at the Charles Town Turf Club. Veterinarians sometimes specialize in either large or small animals. The subjects which veterinary students study include anatomy, microbiology, pathology, physiology, and surgery. Businesses such as racetracks, zoos, and animal shelters often hired veterinarians to work solely for them. (Courtesy collection of Bill Theriault, Bakerton, WV.)

31

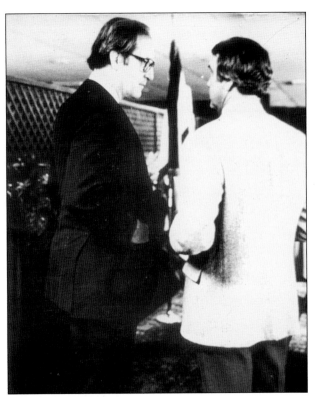

GOVERNOR ROCKEFELLER VISITS.
Gov. Jay Rockefeller, left,
talks to Roger Ramey of the
Charles Town Race Track. John
Davidson Rockefeller IV—born
in New York City on June 18,
1937—was elected governor of
West Virginia in 1976 and in
1980. Rockefeller came from a
Republican family, but he won
a seat in the House of Delegates
as a Democrat. He was elected
to the United States Senate in
1984, 1990, and 1996. (Courtesy
collection of Bill Theriault,
Bakerton, WV.)

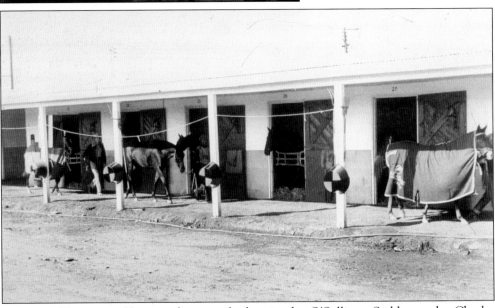

BREAKING YEARLINGS. Here yearlings are broken in the O'Sullivan Stables at the Charles Town Race Track. All thoroughbreds can trace their ancestry back to one of three Arabian stallions—the Byerly Turk, the Darley Arabian, and the Godolphin Barb. Standing from 62 to 65 inches, they weigh from 1,000 to 1,200 pounds and are not allowed to race until they are two years old. This photo appeared on November 13, 1953. (Courtesy collection of Bill Theriault, Bakerton, WV.)

MICKEY GILLEY CONCERT. In this photo a large crowd of fans is entertained at a Mickey Gilley Concert. Mickey Gilley started his career as a pianist and vocalist. Borrowing ideas from his cousin Jerry Lee Lewis, he infused country, rock, blues, and R-and-B into his shows. The movie *Urban Cowboy* was based on Gilley's Club, which eventually closed. Gilley was one of the first country stars to open a theater in Branson, Missouri. (Courtesy collection of Bill Theriault, Bakerton, WV.)

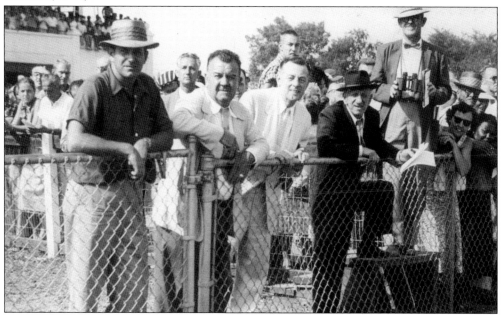

HOLLYWOOD COMES TO THE CHARLES TOWN RACES. Jimmy Durante, in a dark suit and hat, leans on the fence holding a program in his left hand. Standing elevated behind him is track veterinarian Dr. William Trussell, holding binoculars. In vaudeville, nightclubs, movies, radio, the theater and television, Durante gained fame and endearment from his comic singing and clowning. This photo was taken by the Charles Town Turf Club on July 18, 1957. (Courtesy collection of Bill Theriault, Bakerton, WV.)

PIONEER OF SHENANDOAH DOWNS.
H.S. Clopper was one of the pioneers of
Shenandoah Downs. Even though the state
approved it, the debate over the new track
divided the community. Jefferson County
was the only place in the country that had
two racetracks. The joke was that there
were more horses than people in Charles
Town. (Courtesy collection of Bill Theriault,
Bakerton, WV.)

FOUNDER OF SHENANDOAH DOWNS. William
"Lefty" Goldberg was one of the founders
of Shenandoah Downs. In harness racing,
each horse pulls a driver in a sulky, a light
two-wheeled vehicle. There are two kinds of
horses in harness racing—pacers and trotters.
Pacers move both legs on one side of its body
simultaneously, while trotters alternate.
(Courtesy collection of Bill Theriault,
Bakerton, WV.)

SHENANDOAH DOWNS OPENS. Pictured here in 1956 is West Virginia Gov. Cecil Underwood cutting the ribbon. To his left is Bob Leavitt, the manager of Shenandoah Downs. The horse known as the "Great Father" of harness horses was Hambletonian. He was born in 1849 and sired 1,331 horses before 1876, when he died. In the United States, almost all standard breeds can be traced to Hambletonian. (Courtesy collection of Bill Theriault, Bakeron, WV.)

SHENANDOAH DOWNS. This 1959 aerial photo by A. Vernon Davis shows Shenandoah Downs facing east. In the United States, harness races are regulated by USTA, United States Trotting Association. Almost everyone in harness racing belongs to the USTA. The popularity of harness racing increased in the 1940s, when night races and pari-mutuel betting were introduced. (Courtesy collection of Bill Theriault, Bakerton, WV.)

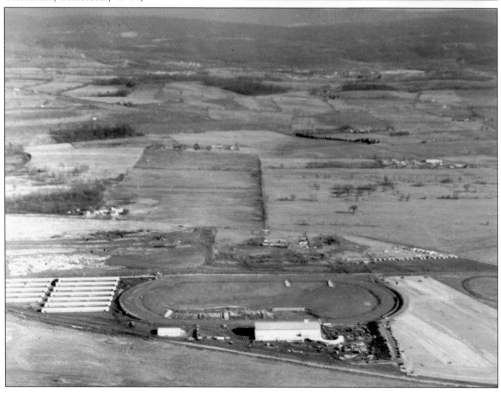

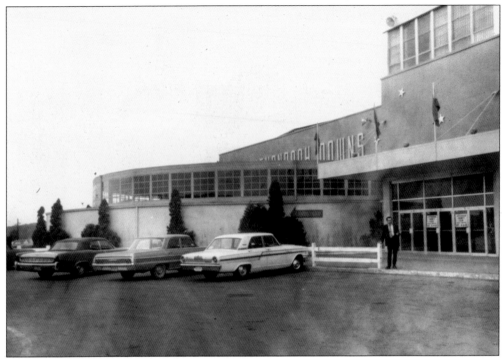

ENTRANCE TO SHENANDOAH DOWNS. In 1976, Shenandoah Downs closed, but reopened again in 1978 when Kenton Corporation purchased both tracks, although that was Shenandoah Downs' last year. In January 1979, Kenton announced that the Charles Town Race Track would close unless Sunday racing was allowed and state taxes were reduced; the threat worked. This photo was taken on October 8, 1970. (Courtesy collection of Bill Theriault, Bakerton, WV.)

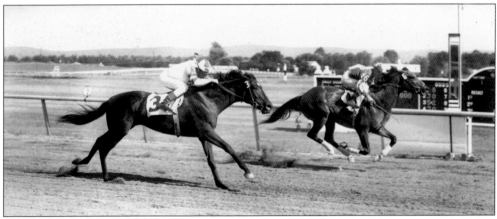

JOE SERVIS WINS. In this July 17, 1958 photo, jockey Joe Servis rides Mighty Cross to a clear win. R. Roy McClarin was the owner and Mrs. G.A. Saportas was the trainer. Joe rode at Charles Town for many years. One of his children, John, went on to become the trainer of Smarty Jones, the horse that won the first two legs of the Triple Crown in 2004. (Courtesy of Dr. Douglas Allara, D.V.M., Charles Town, WV.)

WINNER JOE SERVIS. On July 17, 1958, Joe Servis poses on Mighty Cross. His career as a jockey led three of his four children to have something to do with horse racing. The most well known of his four children is John Servis, the trainer of Smarty Jones. In July 2004, the town of Charles Town welcomed Jefferson High School graduate John Servis home with a big celebration. (Courtesy of Dr. Douglas Allara, D.V.M., Charles Town, WV.)

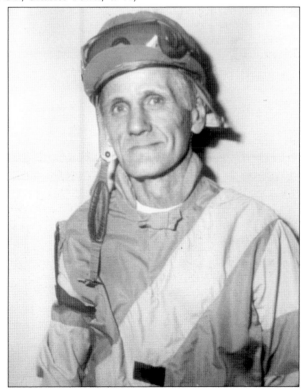

OLDEST JOCKEY. This 1985 photo shows Willie Clark, who at the time was the oldest active jockey in the United States. The skill of the jockey to handle a horse often determines whether the horse wins or loses. Most jockeys weigh about 110 pounds, because a horse is only allowed a specific weight in races. Jockeys wear silks, or colors, which identify the owner. (Courtesy collection of Bill Theriault, Bakerton, WV.)

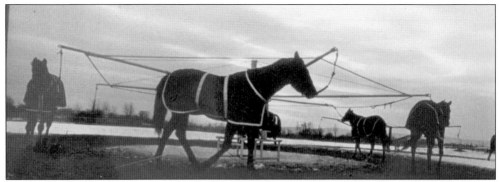

HORSES ON AN EXERCISE DEVICE. In this photo horses exercise at the Charles Town Race Track. The exercise wheel is motorized so the horses walk at a specific pace. Horses have three natural gaits: walk, trot and canter. A gallop is considered to be a fast canter. Horses are examined by veterinarians once or twice a year, and vaccinated yearly against tetanus, influenza, and other diseases. (Courtesy collection of Bill Theriault, Bakerton, WV.)

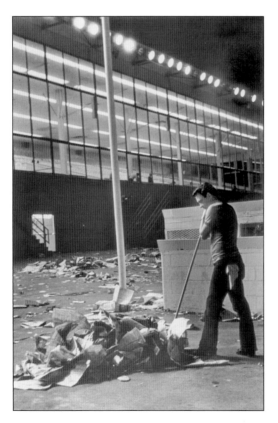

AT DAY'S END. Charles Johnson sweeps up after the night's racing at Charles Town Turf Club. Tons of rubbish are generated each day. Discarding your losing tickets on the ground has become a tradition, along with food and beverage containers. An average person generates approximately 3.75 pounds of trash per day. How much would a racetrack generate? (Courtesy collection of Bill Theriault, Bakerton, WV.)

Four

DAILY LIFE

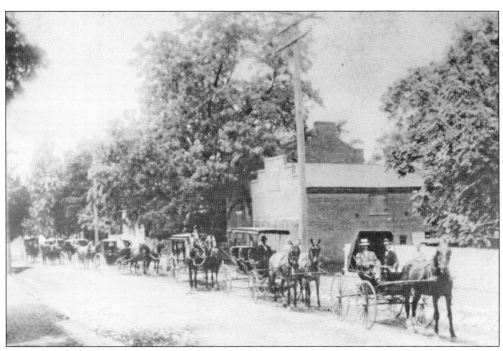

FUNERAL PROCESSION. Pictured here is a funeral procession on West Congress Street in Charles Town. This undated photo is obviously from the "horse and buggy" days, when life expectancy could be as low as 47 to 48 years. Bodies were embalmed if the process could be afforded by the family. (Courtesy collection of Bill Theriault, Bakerton, WV.)

LINK FAMILY REUNION. This c. 1890 photo shows the Link Family Reunion beside the Uvilla Lutheran Church. Uvilla was originally called Union Ville, but Southern sympathizers changed the name to Uvilla. John Adam Link II came from Maryland to Jefferson County around 1800. He served in the Revolutionary War as an ensign in the American Navy. Lord Fairfax granted Shepherd's Tract to Alexander Ogle, the father of Jane Ogle, Link's future wife. (Courtesy collection of Bill Theriault, Bakerton, WV.)

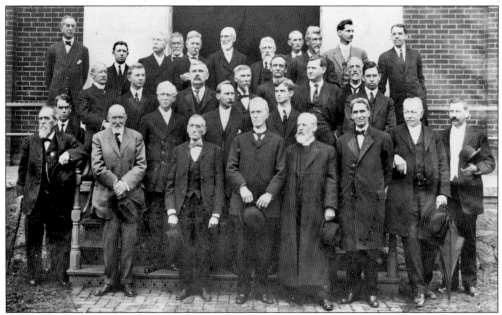

MEN'S BIBLE CLASS. This photo of a Bible class appears to be from the late 19th or early 20th century. Some of the members could even be Civil War veterans, but that is speculation. Note that this is not an integrated study group, either by race or sex. Integration, even in churches, would come much later. (Courtesy of Jefferson County Museum, Charles Town, WV.)

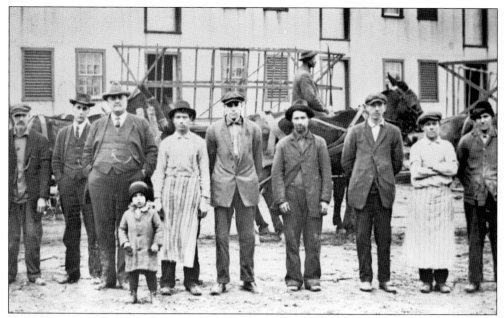

JEFFERSON COOPERAGE. This photo was taken in the early 1900s in Ranson, West Virginia outside of the Jefferson Cooperage. In the cooperage a cooper would make barrels or casks. Casks were barrel-shaped vessels made of staves, headings and hoops and were used to store liquids. Barrels were round bulging vessels which were longer than they were wide. Barrels were used to ship goods as well as for storage of food. (Courtesy collection of Bill Theriault, Bakerton, WV.)

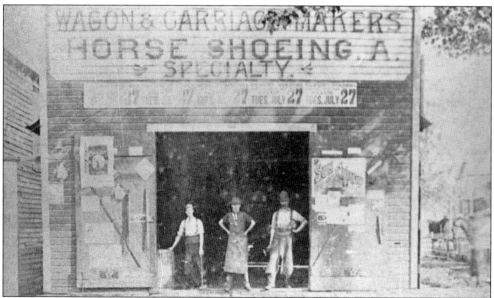

WAGON AND CARRIAGE MAKERS. Pictured in this undated photo is the Wagon and Carriage Makers shop across from the present Masonic Building on South George Street. Horseshoeing was a specialty of theirs. It was very important that wagons or carriages be balanced, well made, strong, and as smooth riding as possible. Training a horse to be a carriage horse took time and skill. (Courtesy collection of Bill Theriault, Bakerton, WV.)

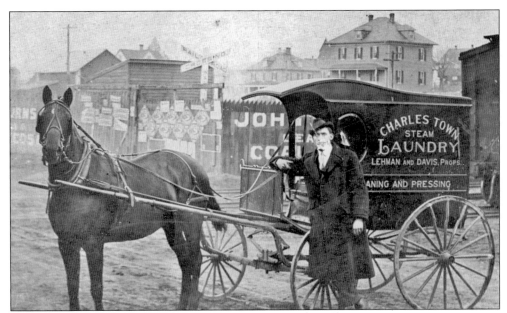

STEAM LAUNDRY. A gentleman stands in front of the Charles Town Steam Laundry wagon on George Street. On the side of the wagon is written "Lehman and Davis Props," an abbreviation for proprietors, and "Cleaning and Pressing." At about the time this photo was taken, a wagon similar to this one could be purchased from $64.25 to $69.95 through the Sears, Roebuck catalogue. (Courtesy of Jefferson County Museum, Charles Town, WV.)

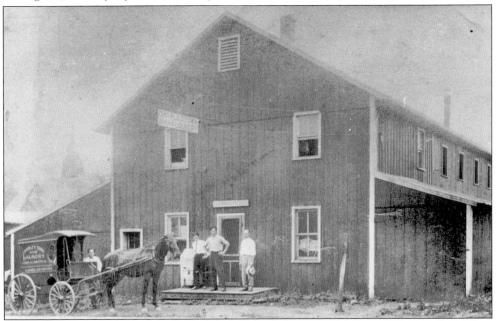

CHARLES TOWN STEAM LAUNDRY PLANT. The date of this photo is sometime prior to 1916, when the Charles Town Steam Laundry burned. Whether it is the same horse and wagon as in the previous photo is not known. Whether the men in the photo are employees, customers, or a combination is also not known. It was probably winter when it burned down because a Mr. Long said that it was "very cold." (Courtesy of Jefferson County Museum, Charles Town, WV.)

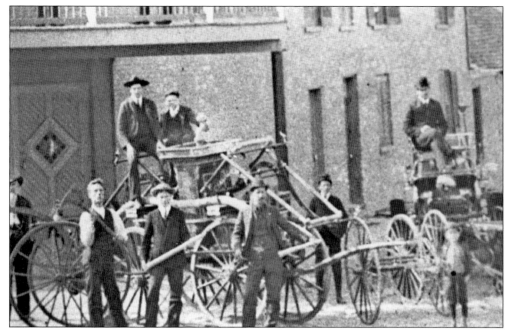

FIRE DEPARTMENT. Here is a hand-operated pumper. This horse-drawn fire engine and hose cart were part of the Citizens' Fire Hall, located on the northwest corner of W. Washington Street and West Street. Citizens' Fire Company of Charles Town was created February 3, 1897. The first local fire was reported to have occurred in 1830. In 1838, a rash of fires were suspected of being caused by an arsonist, although no one was ever arrested. (Courtesy collection of Bill Theriault, Bakerton, WV.)

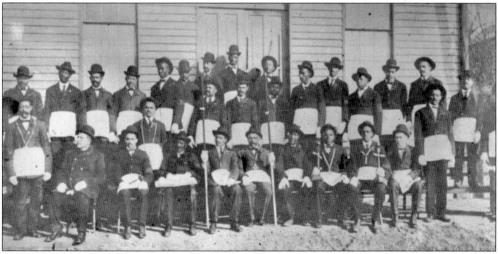

PRINCE HALL MASONS. This 1907 photo shows the Star Lodge No. 1, the Prince Hall Masons, in front of Fisherman's Hall on S. West Street. In no identified order are Thomas Young, Dan Carey, Tom Bailey, Louis Hill, Tom Nelson, Charles Snowden, Sam Dotson, Wesley Tolbert, Adam Taylor, Sam Galloway, Bunt Jackson, Charles R. Ross Sr., S.D. Taylor, James Twyman, William Ross, David Carey, Peter Brooks, Charles A. Ross, Ed Twyman, Sam Tucker, Earl Johnson, L.L. Page, and George Washington. (Courtesy collection of Bill Theriault, Bakerton, WV.)

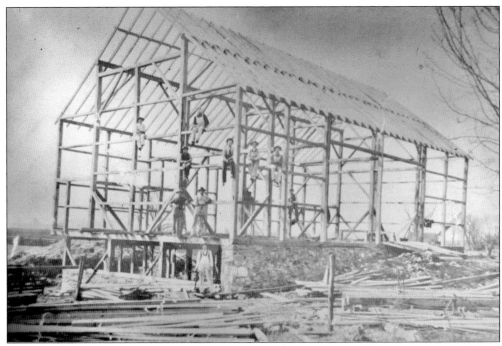

BARN RAISING. This *c.* 1910 shows a barn raising near Leetown, a small community near Charles Town. Barn raisings were common in rural communities. The men would all get together and build the barn for a neighbor while the women prepared and served meals. It was a social event with a purpose. (Courtesy collection of Bill Theriault, Bakerton, WV.)

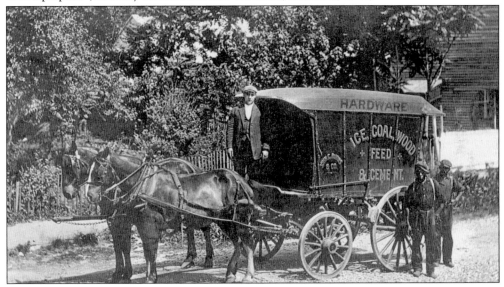

HARDWARE WAGON. This hardware wagon delivered a variety of goods: ice, coal, wood, feed, and cement. This hardware store likely had a permanent location and used the wagon for deliveries only. It is unknown if the driver and the two men were owners or just employees. In Jefferson County in the year 1860, there was an African-American merchant named Joe Hagan, one of eight skilled black men from Harpers Ferry. (Courtesy collection of James Taylor, Charles Town, WV.)

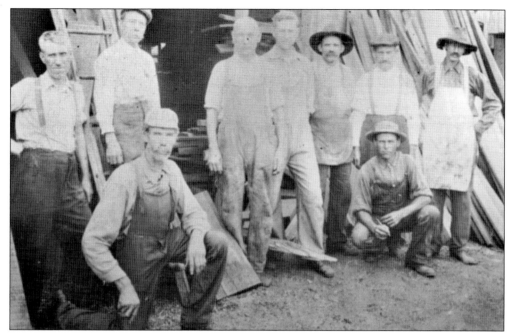

PHILLIPS LUMBER YARD. Phillips Lumber Yard was located on E. North Street and was owned by Oscar Phillips. This *c.* 1910 photo shows, from left to right, (kneeling) G. Anderson, and John M. McCarty; (standing) unidentified, Smith, Will Rodeffer, George Rodeffer, Arthur Lock, Ed Phillips, and unidentified. A lumberyard did a brisk business, as wood was not protected by preservatives as it is today. Often sheds were left to "weather" rather than painting them. (Courtesy collection of Bill Theriault, Bakerton, WV.)

PETER HALL AND ESSIE BROOKINS HALL. Bro. Peter Hall stands beside his wife Essie Brookins Hall in front of their residence. The House of Prayer was the only African-American Pentecostal-Holiness congregation in Charles Town in 1936. For three years, the congregation met in members' homes. Brother Hall's estate provided part of the funds necessary to purchase a building in 1939, located on the corner of Water and Congress Streets. (Courtesy collection of James Taylor, Charles Town, WV.)

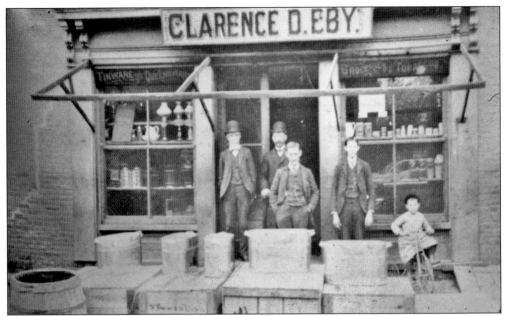

CLARENCE D. EBY GROCERY. Standing in front of the store on W. Washington Street are Clarence Eby, Ed Miler, Paul Eby, and two unidentified people. Notice the lamps in the left window, top shelf, next to what appears to be a teapot or a pitcher. Notice also the barrels and boxes out front, all displaying some sort of merchandise. A young boy sits on the tricycle. (Courtesy collection of Bill Theriault, Bakerton, WV.)

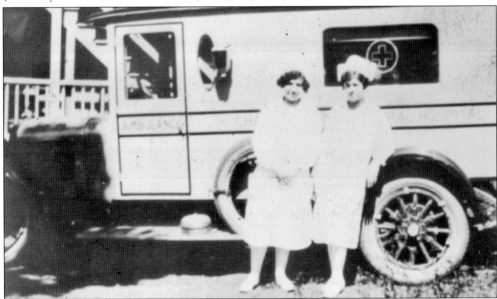

HOSPITAL AMBULANCE. The Charles Town Hospital Ambulance and two nurses can be seen in this undated photo. The first hospital in Charles Town was the second floor of Dr. Richard Venning's home, which provided five bedrooms, one bath, an operating room, and a sterilizing room. Later, he would dedicate the lower part of his home to the hospital also, and would build another house next door for his residence. (Courtesy collection of Bill Theriault, Bakerton, WV.)

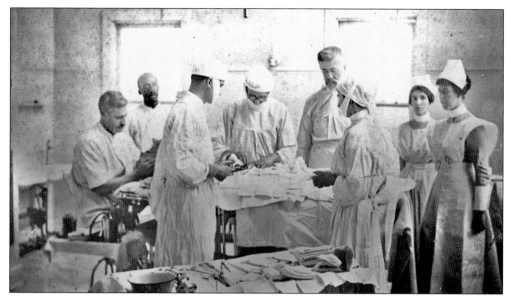

OPERATING ROOM. This 1912 photo, taken at the Old Charles Town Hospital, shows, from left to right, Dr. A.O. Albin, George Rutherford (probably an orderly), Dr. Charles E. Venning (surgeon), Dr. Long (Luray, Virginia) assisting, and Dr. Samuel T. Knott, assisting. To the right are three attending nurses. Charles Town Hospital offered segregated rooms until after the NAACP filed discrimination complaints with the U.S. Department of Health, Education, and Welfare. (Courtesy collection of Bill Theriault, Bakerton, WV.)

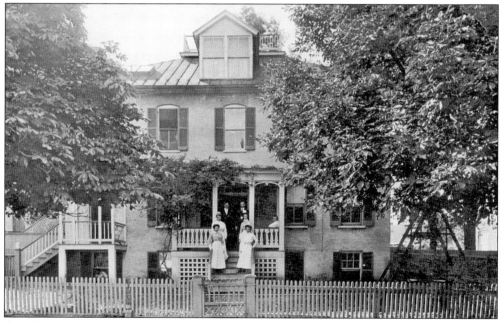

OLD CHARLES TOWN HOSPITAL. In this photo we see the Old Charles Town Hospital on Congress Street in Charles Town. On the steps are at least four nurses with two doctors standing behind them. There appears to be another nurse on the right. A new hospital was built in 1948. The physicians did the best with what they had, which is typical of hard-working Americans yesterday and today. (Courtesy of Jefferson County Museum, Charles Town, WV.)

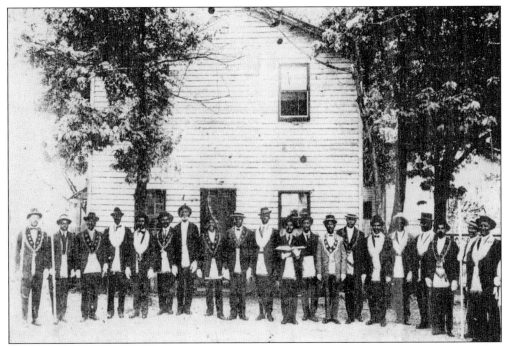

PRINCE HALL MASONS. This 1915 photo was taken near Fisherman's Hall on S. West Street. The name dates to the founder of the first all-black Masonic lodge in America, who was born in the West Indies and moved to Boston in 1765. A self-educated property owner and Methodist pastor, Prince Hall and 14 other freedmen joined a British Army Masonic lodge in Boston. After the Revolution, they formed a separate African American Lodge. (Courtesy collection of James Taylor, Charles Town, WV.)

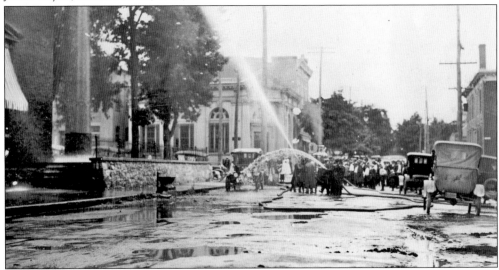

NEW FIRE ENGINE. The fire department tries out the new fire engine and pump. The hose sprays toward the trees in the front yard of the courthouse. In the distance at left is the building that houses city hall today. On the far right is the old jailhouse. This photo dates prior to 1919, the year the jailhouse was razed. Telephone poles are visible but no traffic lights are evident. (Courtesy of Jefferson County Museum, Charles Town, WV.)

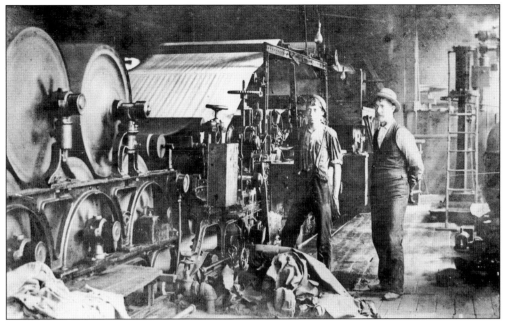

HALLTOWN PAPER BOARD FACTORY. Two men can be seen standing in the aisle; both men are probably employees, although the man on the right is probably in management, based on his attire. The Halltown Paper Board factory originally produced board from straw provided by local farmers. More recently, it produced paper-box board for packing industries. (Courtesy of Jefferson County Museum, Charles Town, WV.)

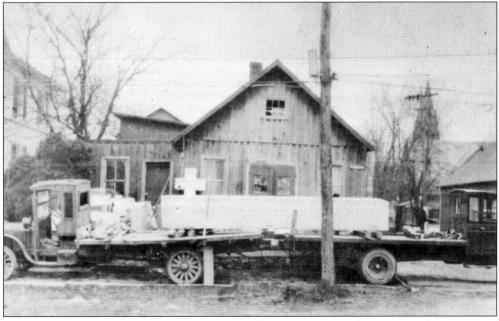

STONE CUTTING BUSINESS. George Diehl had a stone cutting business at the corner of N. George and E. North Streets. A flatbed truck holding large stone slabs can be seen, as well as a large stone cross to the left center of the photo. It was a very exact art—one mistake and the stone would be ruined. (Courtesy of Jefferson County Museum, Charles Town, WV.)

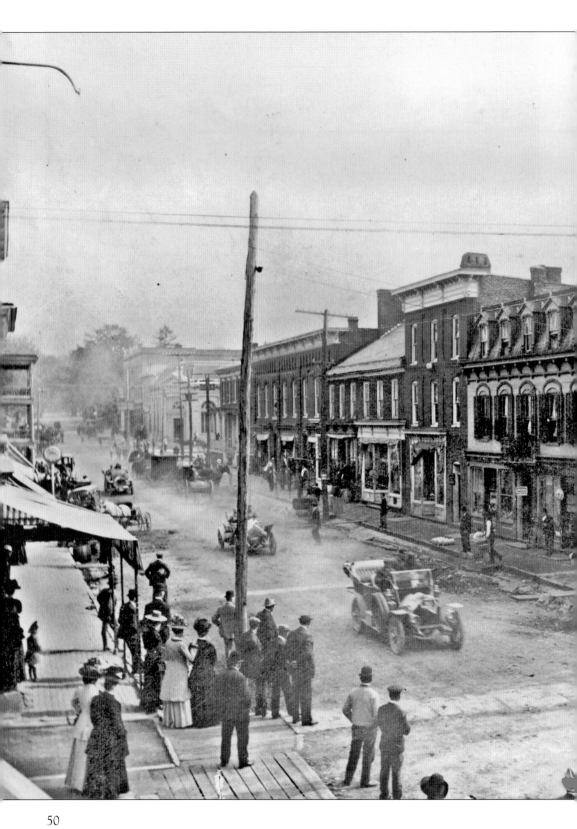

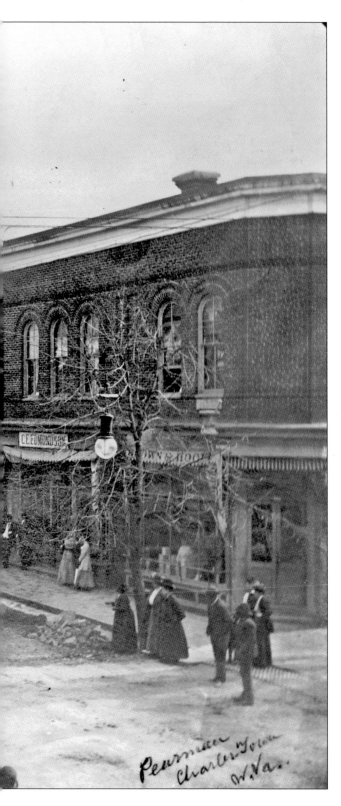

DOWNTOWN CHARLES TOWN. This photo was taken from one of the upper floors of a building along W. Washington Street looking east. Down the street on the right, at the next corner, you can see the building where the city hall is located today. A streetlight is visible on the near corner, as is a telephone pole on the other side of the street. The street is not paved. On the right side of the photo can be seen a board that extends from the sidewalk over the ditch into the road to prevent people from stepping into muddy puddles. Vehicles can be seen going in both directions up and down the street, creating what appear to be dust trails behind them. Horses are also visible, so it is evident that cars had not become the sole mode of transportation. The way pedestrians look at the cars makes one think that cars were still a curiosity. (Courtesy of Jefferson County Museum, Charles Town, WV.)

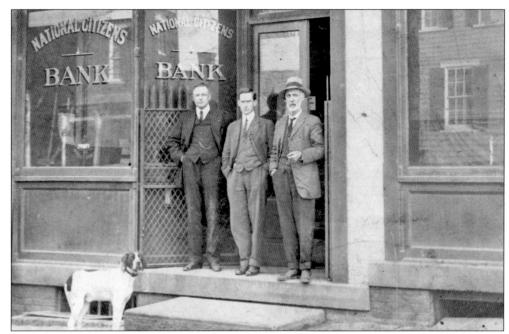

NATIONAL CITIZENS BANK. Pictured standing in the doorway are, from left to right, A.M.S. Morgan, Herman Willis, and S. Davenport Moore. The dog is Starkey. Notice the metal-mesh gate, which was probably installed for safety after banking hours had ended. Based on Mr. Moore's light hat and the lack of overcoats, this photo was probably taken during either spring or summer. (Courtesy of Jefferson County Museum, Charles Town, WV.)

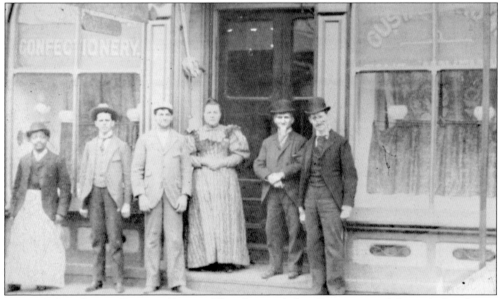

BROWN'S ICE CREAM PARLOR, FRONT. Theodore and Gus Brown owned Brown's Ice Cream Parlor on W. Washington Street, a favorite gathering place for locals. This photo was taken in the early 1920s. Brown's Ice Cream Parlor was the only place in the county that both made and sold ice cream in a variety of flavors. It had an attractive interior with a sizeable fountain on one side and seating in the back. (Courtesy collection of Bill Theriault, Bakerton, WV.)

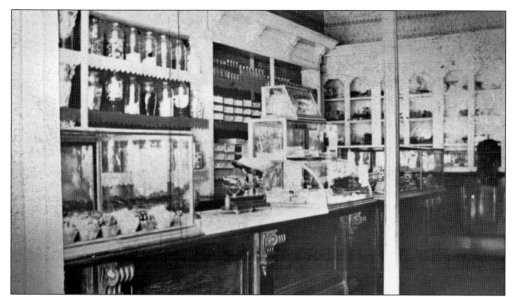

BROWN'S ICE CREAM PARLOR. An ice cream parlor was a popular gathering place for young and old alike. People have always loved ice cream: in 1920, the average person consumed 7.6 pounds of ice cream per year. In 1930, that number rose to 9.8 pounds, and in 1940 it hit 11.4 pounds. Popularity of ice cream kept increasing, and in 1950, the average person consumed 17.2 pounds of ice cream annually. (Courtesy collection of Bill Theriault, Bakerton, WV.)

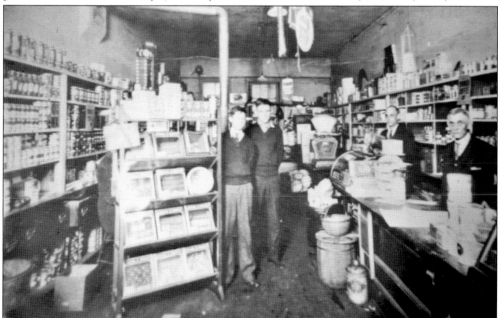

EBY GROCERY STORE. Pictured is the Clarence D. Eby Grocery on W. Washington Street. Standing in front of the counter are D.D. Eby, left, and Cecil D. Eby, right. Behind the counter is Reginald Skinner, and nearer the front on the right is Fred Hammond. Stores such as these were often social hubs for families and friends. Saturday typically was the busiest day of the week, when families came to town to shop. (Courtesy collection of Bill Theriault, Bakerton, WV.)

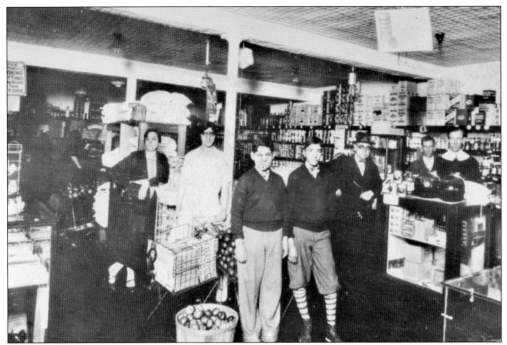

LORENZO GROCERY STORE. The Lorenzo Grocery Store was located on the corner of Charles and Washington Streets. This 1930 photo shows, from left to right, Mrs. Frank Lorenzo, daughter Saverina, son Frank, employee Richard Orndorff, owner Frank Lorenzo, and employees Campbell Woody and Lester Edwards. Although many people had their own gardens, they still needed grocery-store items. In the early 1950s, son Frank Lorenzo sold the store and moved to New Jersey. (Courtesy collection of Bill Theriault, Bakerton, WV.)

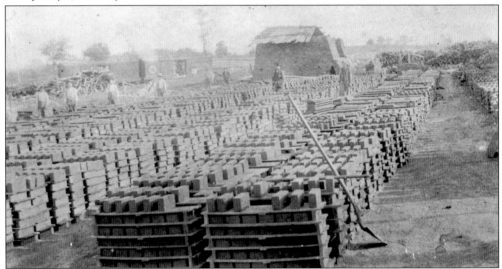

BRICK YARD. Pictured here is the Ranson brickyard, *c.* 1930. As Charles Town continued to grow, it would continue to need new buildings. The little town of Ranson developed as a subdivision of Charles Town at the suggestion of Roger Preston Chew when he served as head of the Charles Town Mining, Manufacturing, and Improvement Company. (Courtesy of Jefferson County Museum, Charles Town, WV.)

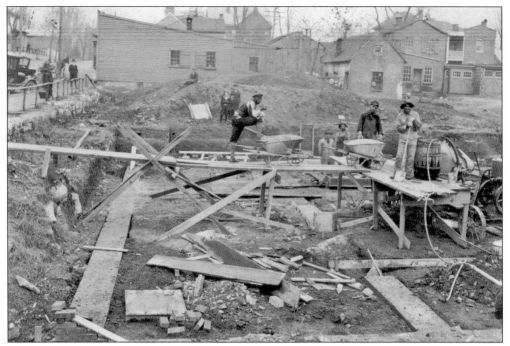

WORKERS ON COUNTY BUILDING. In this 1922 photo, African-American workers construct the County Building. People on the bank and on the sidewalk in the background are observing as the gentlemen in the pit are working. In 1922, the average annual compensation for construction workers was $1,459, but it is questionable whether these workers were paid that much. (Courtesy collection of James Taylor, Charles Town, WV.)

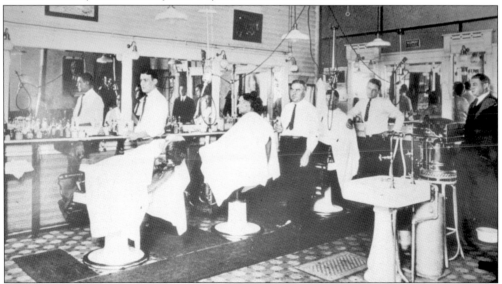

ENNIS BARBER SHOP. Pictured in the early 1930s is the interior of the Ennis Barber Shop, located on N. Charles Street. Mr. Alvin M. Ennis Sr. is standing by the first chair on the left. Son Thomas E. Ennis Sr. stands near the center chair. On the right is son Wilbur "Sally" Ennis. Others are not identified. It seems the barber shop was a family venture. (Courtesy collection of Bill Theriault, Bakerton, WV.)

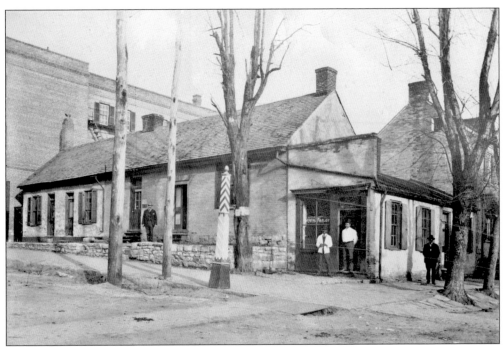

Jim Thompson's Barber Shop. This photo shows Jim Thompson's Barber Shop at 101 E. Washington Street. Lawyers' Row was next door, which extended to the Thomas Jefferson Hotel, the large building to the left. (Courtesy collection of Bill Theriault, Bakerton, WV.)

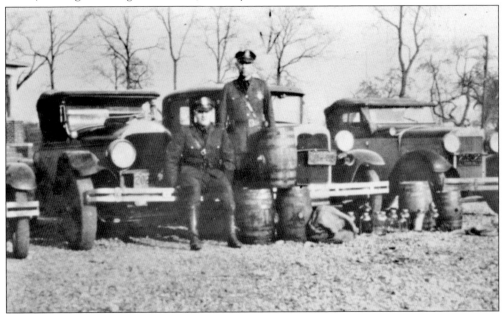

Bootleggers Caught. This c. 1930s photo shows four Maryland cars and some 60 gallons of confiscated whiskey. The raid was conducted by Merle E. Alger, a Charles Town District constable (seated on bumper), and Ralph Reger, the first West Virginia State Trooper stationed in Charles Town. The drivers of the cars were turned over to federal agents and prosecuted for violating Prohibition. (Courtesy collection of Bill Theriault, Bakerton, WV.)

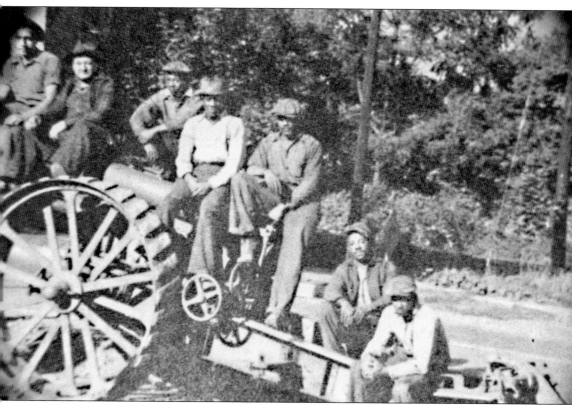

WORKERS RESTING. The photo is undated, but it appears to between 1920 and 1940, based on the hats the men are wearing. The average weekly earnings in 1934 amounted to $22.97. Workers averaged 28.9 hours per week at 80¢ per hour. In 1935, workers increased their salaries by one and a half cents per hour, and their work week increased to 30.1 hours, making their average weekly income $24.51. (Courtesy collection of James Taylor, Charles Town, WV.)

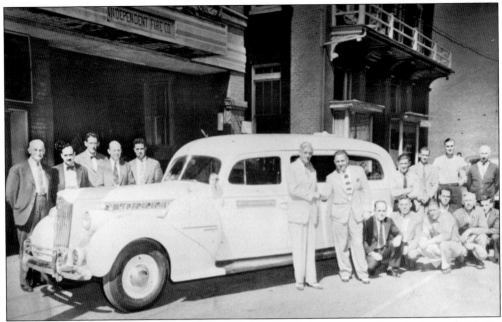

INDEPENDENT FIRE COMPANY AMBULANCE. The new ambulance entered use in the early 1940s. Standing in back are, from left to right, Dr. A.O. Albin, Dr. Merle Fox, Dr. Marshall Glenn, Dr. William Worden, and Dr. John L. van Meter. Standing in front are Dr. G.P. Morison and Charles F. Reininger, president of the fire company. Squatting are fire company members Jimmy Sites, Kable Johnson, N. Clark Furr, Charles Coulter, Neil Anderson, and Jimmy Fields. Standing behind the vehicle are Mutt James, Ed McDonald, Creamer Gravey, and Lowell Anderson. (Courtesy collection of Bill Theriault, Bakerton, WV.)

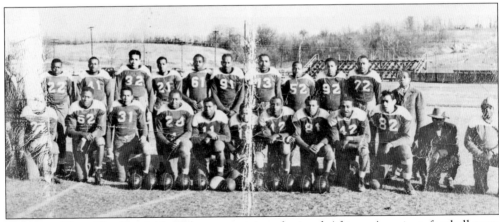

HOMICIDE KIDS. The Homicide Kids was a semi-professional African-American football team organized in the 1940s. This photo was taken at the American Legion Field in Charles Town. Spectator sports have always been popular with the public, and they have steadily increased over the years. (Courtesy collection of James Taylor, Charles Town, WV.)

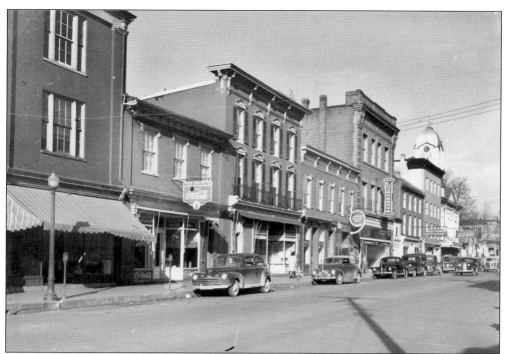

DOWNTOWN, 1940s. Businesses along W. Washington Street have not changed much over the years. Looking across to the north, three of seven buildings pictured contain restaurants. The name of the first restaurant on the left is unknown, but they served Coca Cola. Two doors to the right is the Western Auto Associates Store. Next to Western Auto is Luxenberg's Department Store. Beyond Luxenberg's are two restaurants, one of which is named Southern Restaurant. The cupola of the courthouse can be seen on the right. (Courtesy of Jefferson County Museum, Charles Town, WV.)

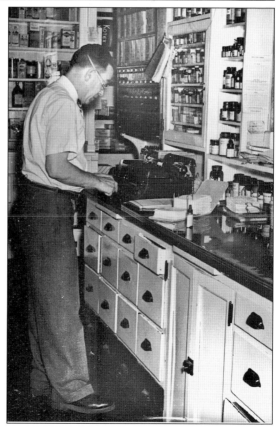

PHARMACIST AT WORK. This 1947 photo was taken in Nicholls-Stuck Pharmacy. Pharmacist Dr. Daniel Shirley Nicholls is shown filling a prescription. The number of pharmacists has steadily increased over the years. In 1900 there were 46,000 nationwide. By 1950 there were 90,000. The photographer was Edwin Fitzpatrick. (Courtesy collection of Bill Theriault, Bakerton, WV.)

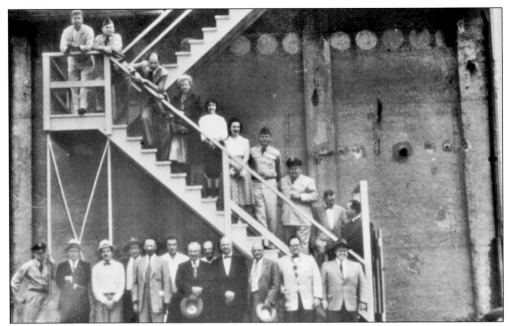

CIVIL DEFENSE WATCH TOWER. The watchtower was located on the roof of a building on Fairfax Boulevard in Ranson. This photo was taken at the back of the building. Pictured are, from left to right, (front row) Air Force Sgt. Thurman White, T.A. Lowery, Edward Poole, Bernie Barr, Bradley Nash, Deputy Assistant Secretary of the Air Force Steve Stone, C. Manning Smith, and George "Flicker" Mullen; (back row) Steve Clopper and an unidentified Air Force recruiter; at the bottom of the steps is F. Dean Nichols. (Courtesy of collection of Bill Theriault, Bakerton, WV.)

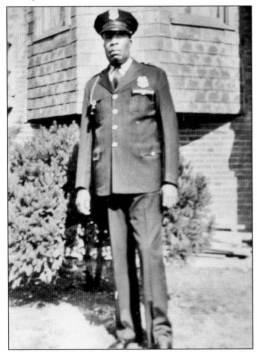

POLICEMAN IN CHARLES TOWN. Pictured is a uniformed policeman in a c. 1950s–1960s photo. In 1910, there were approximately 68,000 policemen nationwide, and by 1950, that number had increased to 197,000. As crime increased, the need for policemen increased. (Courtesy of collection of James Taylor, Charles Town, WV.)

Five

EDUCATION

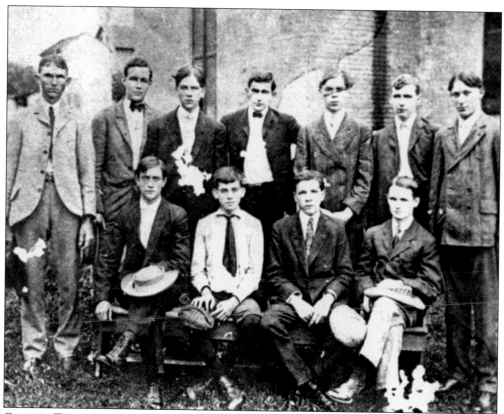

CHARLES TOWN ACADEMY. This undated photo shows the class of the Charles Town Academy. On June 28, 1797, Capt. Samuel Washington was given a bond for the lot on which the school was built. Enrollment gradually declined, and the principal resigned in 1905 because of insufficient patronage. The school was razed in 1912. Students are, from left to right, (front row) Bernie Johnson, Thornton Perry, H.O. Wilk, and Maynard Touchard; (back row) Bob Gracey, Willard Osbourn, Cliff Alden, teacher John Warner, Auroy Mack, Elser Mathena, and Wilson Moler. (Courtesy collection of Bill Theriault, Bakerton, WV.)

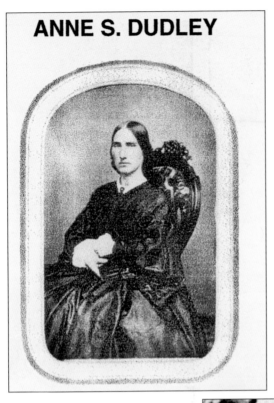

ANNE S. DUDLEY

ANNE S. DUDLEY. Anne Dudley was the first teacher in the African-American school she opened in Charles Town. She was employed by the Free Will Baptist Home Mission Society and was sent south to teach after the Civil War. She arrived in November 1865 in Harpers Ferry, and in December she was sent to Charles Town. The following April she was transferred to Martinsburg, where she taught school and helped establish the Freewill Baptist Church. (Courtesy of collection of James Taylor, Charles Town, WV.)

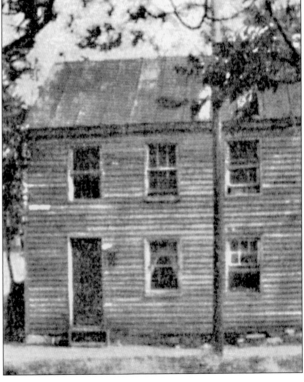

FIRST AFRICAN-AMERICAN SCHOOL. The Freedmen's Bureau, working with the American Missionary Association, established this school in 1865 on Liberty Street. Achilles Dixon allowed Anne Dudley to use a room in his house as a classroom. Dixon, one of 540 freedmen in Jefferson County in 1850, owned both a home and a blacksmith shop. In April 1866, Anne Dudley was replaced by Miss Phebe Libby and Mrs. M.W. Smith. (Courtesy of collection of James Taylor, Charles Town, WV.)

SARA JANE FOSTER. Sara Jane Foster was one of the Home Mission Society members who came to Jefferson and Berkeley Counties to establish churches and schools for the newly freed slaves. After many years of hard work and struggle, schools would be established for African-American students. Attendance sometimes would be sporadic because there were farm chores that needed to be done. (Courtesy of collection of James Taylor, Charles Town, WV.)

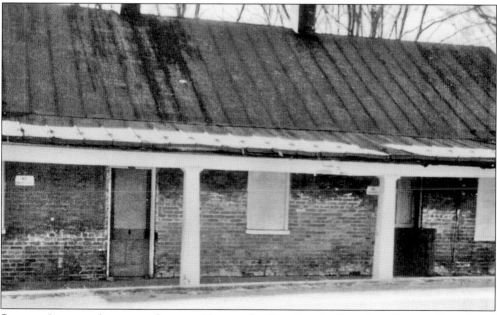

SECOND AFRICAN-AMERICAN SCHOOL. Next to the Zion Baptist Church at Summit Point Road and Middleway Road sits the second African-American school in Charles Town. Thomas Davis sold the lot to the Charles Town District Board of Education for $100. The brick school was built some time between 1868 and 1874 and was known as the Charles Town District Colored School. Littleton L. Page was the first teacher and principal. (Courtesy of collection of James Taylor, Charles Town, WV.)

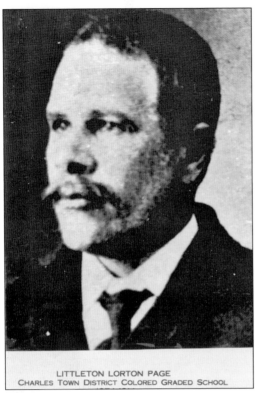

LITTLETON LORTON PAGE
CHARLES TOWN DISTRICT COLORED GRADED SCHOOL

LITTLETON LORTON PAGE. Born into slavery, Page possibly used the Underground Railroad to escape to the North and fought in the Civil War, where he served as Littleton Lorton's page. After the war Lorton helped Page get an education. Page had no name and only answered to "Page," and Lorton suggested that Page take his name, which he did. Page came to Charles Town, where he served as principal of the Charles Town District Colored School for 40 years, beginning in 1874. (Courtesy of collection of James Taylor, Charles Town, WV.)

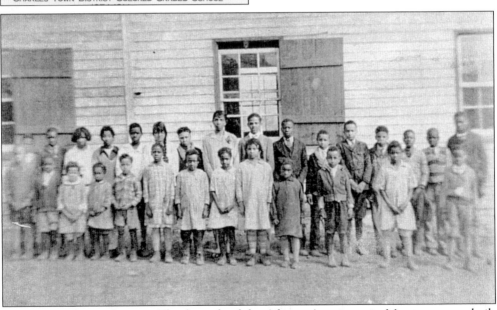

MYERSTOWN BLACK SCHOOL. The first school for African Americans in Myerstown was built in 1875 on a lot sold by Fisher A. Lewis. The school, located on Myerstown-Rippon Road, is no longer standing. In 1936, the school closed, and the students began attending at the Eagle Avenue School in Charles Town. One of the teachers at Myerstown was Miss Annie Watkins, pictured above in the center of the back row. (Courtesy of collection of James Taylor, Charles Town, WV.)

PHILIP JACKSON. Jackson was born January 11, 1869, in Virginia and graduated from Storer College. Around 1887, he was appointed assistant to Mr. Page. Jackson became principal when Mr. Page retired, and he served until his death in 1937. The following year, the first high school for African Americans was established in Jefferson County, named Page-Jackson High School. The school's first class graduated in 1942, and it closed in 1965. (Courtesy of collection of James Taylor, Charles Town, WV.)

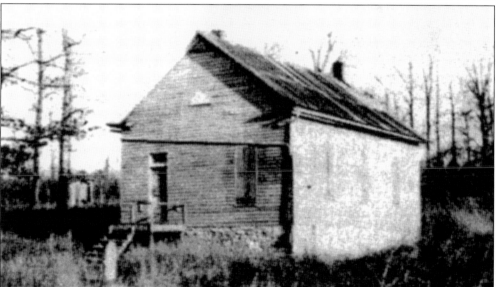

WOODBURY SCHOOL. The Woodbury School was located on Leetown-Kearneysville Road, about half a mile from Leetown. It probably opened in 1887, replacing an earlier school that dated to around the 1850s. Woodbury was originally a school for white students. In 1911, a new two-room brick school was built to replace Woodbury, and African-American students "inherited" the school. They used it for two years before it closed for good in 1913. (Courtesy of collection of James Taylor, Charles Town, WV.)

MECHANICSTOWN BLACK SCHOOL. John Myers sold a lot in 1891 to Charles Town District Board of Education for the Mechanicstown School for African Americans. Mrs. Elsie Clinton was a teacher in 1934 when the school closed. She also taught in the Skeetersville School in Duffields. After Mechanicstown Black School closed, Mrs. Clinton transferred to the Eagle Avenue School in Charles Town. (Courtesy of collection of James Taylor, Charles Town, WV.)

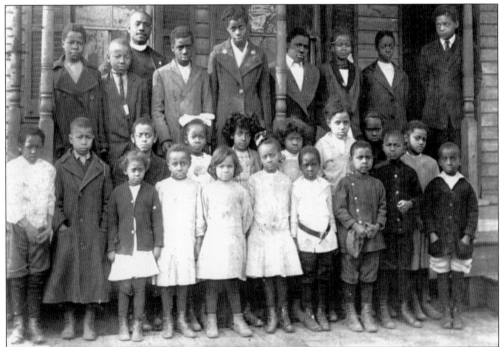

EARLY AFRICAN-AMERICAN SCHOOL. Although there is no date, many of the students are identified; they are, from left to right, (first row) Norman Saul, B. Johnson, Elizabeth Williams, Hallie Rutherford, Bruce Jackson, Mary Russ, Zeke Wilson, Payne Taylor, Willis Taylor, and J. Rutherford; (second row) Sisumond Taylor, Gertrude Brown Lawson, Ruth Tucker, Margaret Jackson, Josephine Luckett, Helen Burman, and Georgia Cool; (third row) Julia Rutherford, John Rutherford, Lem Wise, ? Wise, ? Rutherford, two unidentified, and Louis King; (fourth row) Reverend Yearwood. (Courtesy of collection of James Taylor, Charles Town, WV.)

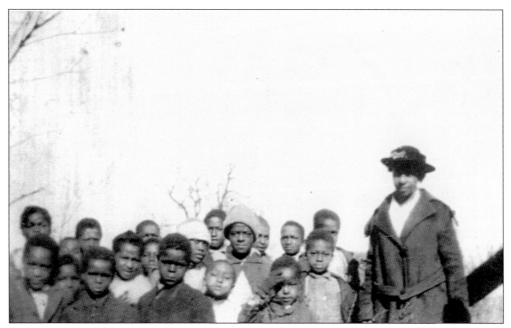

SKEETERSVILLE. African-American students attended a one-room school in Duffields, in an area known as Skeetersville. The Skeetersville school might have opened when the Oak Grove School closed in 1930. Skeetersville closed in 1935 or 1936. Mrs. Elsie Clinton is the teacher in this 1919 photo. (Courtesy of collection of James Taylor, Charles Town, WV.)

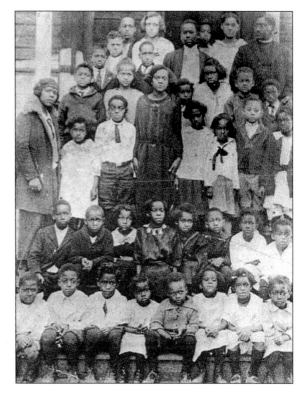

ST. PHILIP'S. Students at St. Philip's Parochial and Industrial School (located on Lawrence Street) are, from left to right, (first row) James Russ, Carl Morris, Frank Buford, Mildred Mitchell, Morgan Crittendon, Lucille Baylor, Cleo Morris, and Pearl Stevenson; (second row) ? Morris, unidentified, Paul Black, Mary Virginia Walker, unidentified, Margaret Crittendon, George Mitchell, Wilbur Drummond, Nethersole Ross, and Virginia Taylor; (third row) Harold Morris, Alezia Taylor (Brooks), Alice Bradford, Frederica Morris, Leo Harris, Ethel Stevenson, Pete Williams, Hugh Crittendon, Katherine Lee, Margaret Taylor, Dorothy Williams, Charles Baylor, Jessee Bradford, Lyle Brown, Ernest Parker, Agnes Parriot, Rev. A.N.B. Boyd, Mary Ellen Rideoutt, Jeannetta Baylor, Lewis Johnson and Carl Tynes. (Courtesy of collection of James Taylor, Charles Town, WV.)

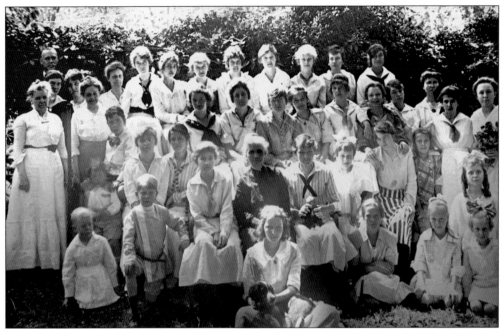

STEPHENSON'S FEMALE SEMINARY. Although this photo is undated, we can probably date the photo to the late 19th or early 20th century based on the clothing styles wore by the women. Mrs. C.N. Campbell is in the middle at front. Dr. McMurray is in the extreme back on the left. The site was operated as The Inn after the school closed. The photo is by Edwin Fitzpatrick. (Courtesy of collection of Bill Theriault, Bakerton, WV.)

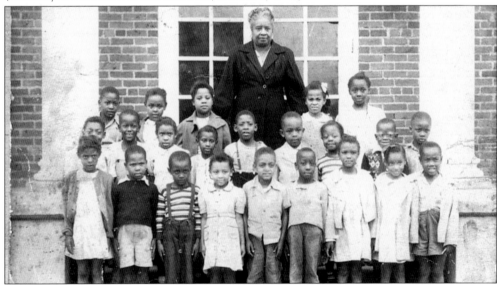

EAGLE AVENUE ELEMENTARY SCHOOL. A devoted teacher stands behind her class at Eagle Avenue Elementary School. The school began when the lot was sold by George and Emily Washington in 1894 for $500 to the Charles Town District Board of Education. That lot would become the home of the Eagle Avenue School for African-American children. The Eagle Avenue School was the last black school in Jefferson County to close. (Courtesy of Collection of James Taylor, Charles Town, WV.)

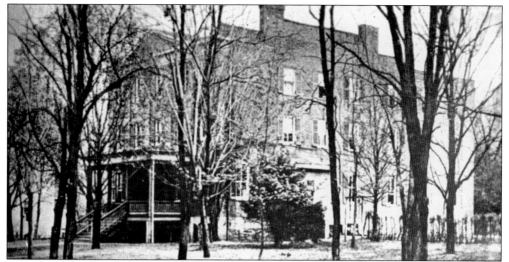

STEPHENSON FEMALE SEMINARY, 1900. This photo shows the Stephenson Female Seminary around 1900. This site, next to St. Thomas Lutheran Church on E. Washington Street, was later converted into apartments. During most of its operation, Dr. Charles N. Campbell directed the school. Dr. Campbell operated a boarding and day school. It operated for about two years and later became the John Stephenson Seminary. (Courtesy of collection of Bill Theriault, Bakerton, WV.)

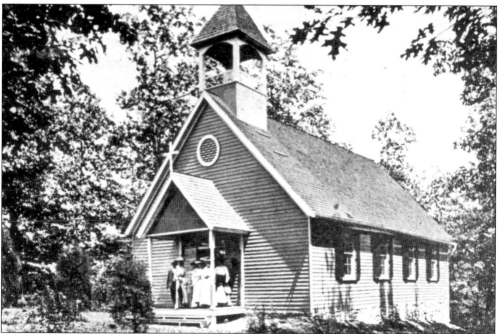

ST. ANDREW'S MOUNTAIN MISSION. St. Andrew's was established by the Episcopal Diocese of West Virginia as an industrial school for children who lived in the mountains. The mission was located on the east side of the Shenandoah River, about four miles southeast of Charles Town. Subjects included cooking, soap making, harness- and shoe-repair, weaving, dairying, and dressmaking. Academic work was also taught, but eventually that aspect was turned over to the public school system. (Courtesy of Jefferson County Museum, Charles Town, WV.)

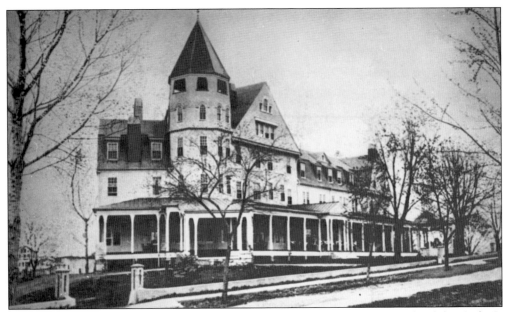

St. Hilda's Hall. Pictured is St. Hilda's Hall in Ranson, the Chevron School for Girls. It was located in the 100 block of Third Avenue and was first established as Powhatan College for Girls. The building was converted into a rooming house when the school ceased operation; workers and visitors to the Charles Town Race Track lodged here. Fire eventually destroyed the building c. 1937–1938. (Courtesy of collection of Bill Theriault, Bakerton, WV.)

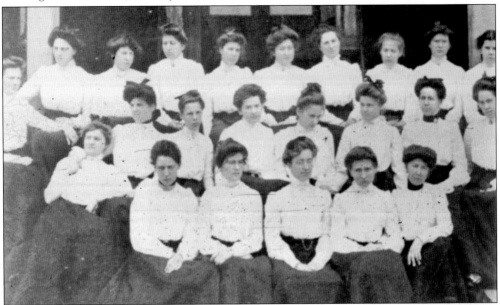

Powhatan Classes of 1905 and 1906. Members of the class of 1905 included Brownie Yeager, Elizabeth Wysong, Lizzie Cockrell, Goldie Yeager, Lizzie Kercheval, Estelle Horn, Elizabeth Frasier, Katie Noland, Frances Wager, and Bessie Walker. Included in the 1906 class were Abbie Beavers, Susie le Foe, Sadie Miller, Vallie Sutherland, Hattie Bradley, Winnie Ely, Caroline Brubaker, Nannie Heidwohl, Flossie George, and Pearl Burr. Powhatan opened in 1900 and closed in 1914. (Courtesy of collection of Bill Theriault, Bakerton, WV.)

HALLTOWN COLORED SCHOOL. This one-room school is still standing today behind the Halltown Memorial Chapel. Halltown closed in 1901, and classes began in the basement of an African-American church near Deck's Crossroads. Two-thirds of the students were from Shepherdstown, so the school closed and Halltown reopened. A new school was built in 1908 and was used until 1930, when students transferred to the new Grandview School in Bolivar. (Courtesy of collection of James Taylor, Charles Town, WV.)

OLD STONE SCHOOLHOUSE. Pictured here is the Old Stone Schoolhouse in Ranson off Fairfax Boulevard. The photo dates from 1908–1910. The gentleman standing on the right is Wright Denny, an important educator in Jefferson County. In the back row, third from the left, is Ethel Royer (Virts). Also in the back row are the Burns twins. Notice how "dressed up" the students seem to be. (Courtesy of collection of Bill Theriault, Bakerton, WV.)

STEPHENSON SEMINARY. This class picture was taken in 1911. Many of the students in the back row were out-of-town boarders, while children in the front row were from Charles Town. The students are, from left to right, (front row) Frances Luke, Roger Milburn, "Toodie" Hoof, unidentified, Mayo Tabb, Cleon Shutt, Florence Morgan, unidentified, and Sarah Philips; (back row) two unidentified, Eliza Perry, Martha Philips, Claudia Wilcox, four unidentified, ? Higgs, ? Higgs, Mary Morrow, Harriet Ware, and Corrine Riley. Others are unidentified. (Courtesy of collection of Bill Theriault, Bakerton, WV.)

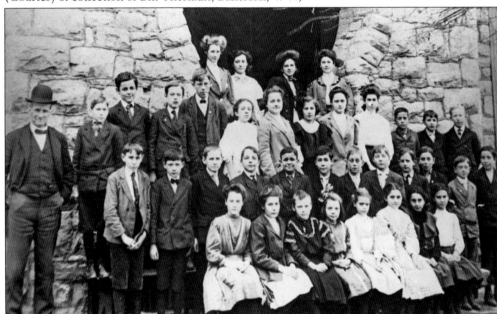

WRIGHT DENNY SCHOOL CLASS. In this undated photo is a school class by Ranson Town Hall. Mr. Wright Denny is on the extreme left wearing the derby. The four women in the back row are teachers. Mr. Wright Denny taught in Charles Town for years. Wright Denny Elementary School was named in his honor. The photo is by Edwin Fitzpatrick. (Courtesy of collection of Bill Theriault, Bakerton, WV.)

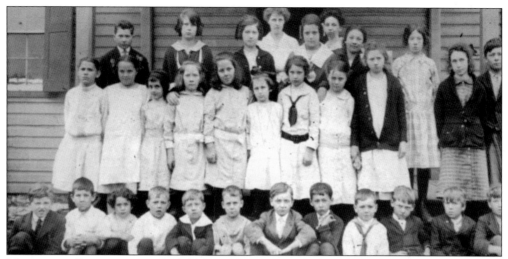

MIDDLEWAY ELEMENTARY, 1915. Taken May 20, 1915, this photo shows the students and teachers, from left to right, (first row) Harlan Watson, Alberta Brining, Lawrence Nicely, John Castleman, Robert Smith, Lyndon Janney, Lester Watson, Leonard Mason, Allen Lyne, Roy Swatz, Tom White, and Leonard White; (second row) Page Moore Henry, Bernice Woods, Margaret Nicely, Nellie Pine, Eva Pine, Mary Myers (Whittington), Edna Nicely (Pifer), Bruce Castleman, Pearl Castleman, Mary Janney, and Frank Pine; (third row) Harry Nicely, Viola Underwood, Blanche Pine, Corrine Underwood, Dulcy Cain, and Margaret Snyder; (back row) Lulu Jennings Shuall and Julia Barnes, teachers. (Courtesy of collection of Bill Theriault, Bakerton, WV.)

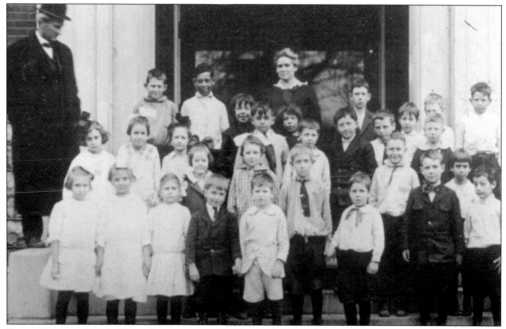

FIRST GRADE, 1916. This class picture was taken of the higher first grade in 1916. In the rear at the left is principal Wright Denny. In the middle of the back row is teacher Anna Baker, in the dark dress. Sixth and seventh from the left in front are Abner Hockensmith and Ray Trussell. (Courtesy of collection of Bill Theriault, Bakerton, WV.)

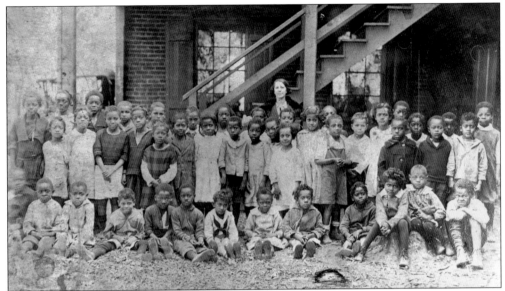

CHARLES TOWN DISTRICT COLORED SCHOOL. In this *c.* 1920 photo are the students of Charles Town District Colored School with teacher Mrs. Cerelle Craven. This school was located on Eagle Avenue in Charles Town. As with most African-American schools of the time, it was under-funded. On September 24, 1966, the building was destroyed by fire. (Courtesy of collection of James Taylor, Charles Town. WV.)

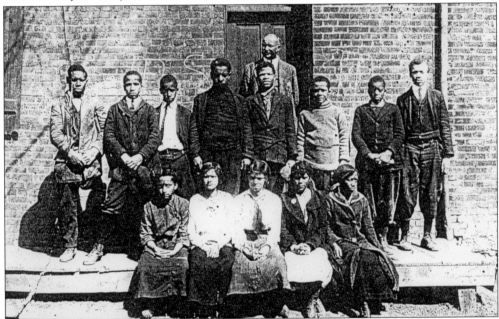

CHARLES TOWN DISTRICT COLORED SCHOOL. Phillip Jackson is pictured with students from the Charles Town District Colored School located on Harewood Avenue. Only 13 students were in this photo, 8 young men and 5 young women. Mr. Phillip Jackson was instrumental in the education of African-American children in the county for many years. Page-Jackson High School was named in honor of his and Mr. Page's contributions. (Courtesy of collection of James Taylor, Charles Town, WV.)

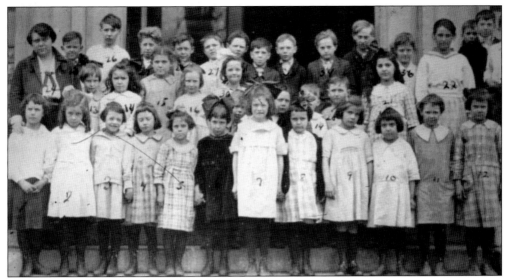

WRIGHT DENNY SCHOOL. Pictured in this 1920 class photo are, from left to right, (front row) Mary Louise Phillips, Dorothy Lugar, Margie Atkins Davis, Kathryn Wright Byrd, Agnes Fadeley, Virginia Kearns, Agnes Smith, Ethel Jackson, Ella Paige Mason, Helen Blum, Virginia Armstrong, and Virginia Palmer Ware; (middle row) three unidentified, ? Darlington, Charles Skinner, Harvey Russell, Ralph McCarthy, Berry Rodefer, Soborine Lorenzo, unidentified, and William Souders; (back row) teacher Katherine Baylor, John Rissler, two unidentified, Arthur Alexander, William Bell, Myrtle Bell, Daniel Armstrong, Martin Glaize, Gardner Darlington, Chester R. Roper, two unidentified, Leslie Alger, and Kenneth Bush. (Courtesy of collection of Bill Theriault, Bakerton, WV.)

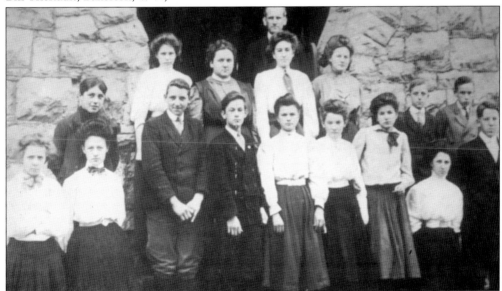

RANSON ELEMENTARY SCHOOL. Elementary schools at the time this photo was taken included students through the eighth grade. This photo of Ranson Elementary School students appears to be an upper grade taken during first quarter of the 20th century, based on clothes and hairstyles. Mr. Wright Denny is standing in the rear of the group, and Emma Louthan is standing in the center of the first row. (Courtesy of collection of Bill Theriault, Bakerton, WV.)

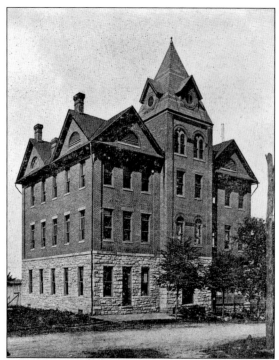

KEYHOLE BUILDING. This undated photo shows the Keyhole Building, which was used as Charles Town High School. In April 1922, the board of education purchased the Timberlake Property on W. Congress, and used it for seven years as the high school. Fifty-two percent of Jefferson County's students enrolled in schools beyond high school from 1934 to 1937. Until a black high school was established, African Americans attended high school at Storer College. (Courtesy of Jefferson County Museum, Charles Town, WV.)

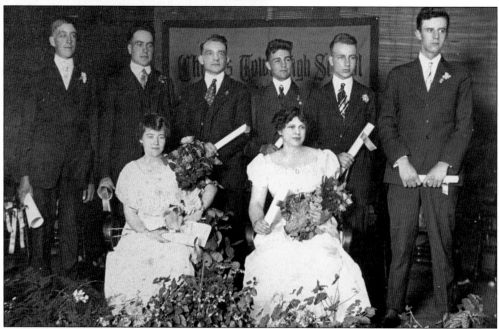

GRADUATING CLASS, CHARLES TOWN HIGH SCHOOL. This photo is undated, but one person is identified: Katherine Baylor is on the right. Generally, the poor or working class students could not afford to attend school. They stayed home to help either by having odd jobs or providing childcare while their parents worked. Affluent families could afford to send their children to school because the children were not needed to make a living. (Courtesy of Jefferson County Museum, Charles Town, WV.)

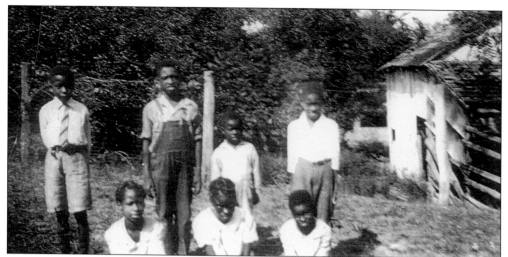

MECHANICSTOWN BLACK SCHOOL. This *c.* 1932 photo shows the Mechanicstown Black School. The building, on Route 9 South, is today privately owned. After the school closed in 1934, Mrs. Elsie Clinton and her students were transferred to Eagle Avenue School in Charles Town. Students are, from left to right (front row) Katherine Clinton, Marie Davie, and Elsie Davis; (back row) Wayman Clinton, Leslie Jones, William Shorts, and James Davenport. (Courtesy of collection of James Taylor, Charles Town, WV.)

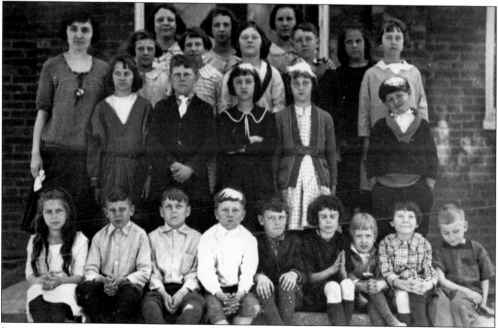

LEETOWN SCHOOL. This undated photo shows, from left to right, (first row) Mary Price, Edwards Hill, Alton Grove, Mason Watson, Edgar Collis, Clarence Fritts, Kitty Coyle Rodgers, Clark Furr, Getti Strider Coyner, and Bob Strider; (second row) Virgie Clipp Forsythe, Clifton Collis, Vivian Myers, Virginia Edwards, and William Collis; (third row) teacher Grace Burham Cline, Virginia Grove Krouse, Jeanette Staubs Pitzer, Maxine Fritts Blue, Fred Custer, and Ella Barney Lemaster; (fourth row) Edith Milburn Demory, Rhode Staubs, Lucille McCoy Staubs, and Frances Bradshaw. (Courtesy of collection of Bill Theriault, Bakerton, WV.)

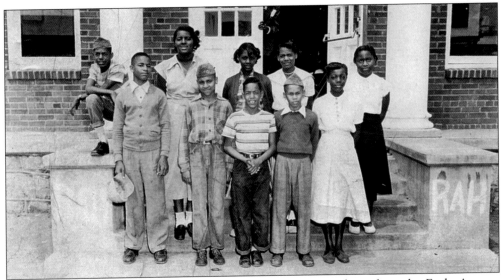

EAGLE AVENUE SCHOOL. This c. 1930s–1940s photo shows students from the Eagle Avenue School. When the school was built, it consisted of four rooms. Eventually, a replacement school was built and dedicated on December 27, 1929, when the Star Lodge No. 1 Masons laid its cornerstone. The new six-room Eagle Avenue School was built in the same general area and included an office and an auditorium. The name given to the school was the Charles Town District Colored School. The principal was Mr. Jackson. On September 24, 1966, the school was destroyed by fire. (Courtesy of collection of James Taylor, Charles Town, WV.)

BURNING OF POWHATAN COLLEGE. This photo shows the burning of Powhatan College on December 11, 1937. Powhatan College had opened 37 years earlier. It was under the directorship of Prof. S.P. Hatton. The school went into bankruptcy and closed its doors at the end of the 1913–1914 session. (Courtesy of collection of Bill Theriault, Bakerton, WV.)

First Graduation Class

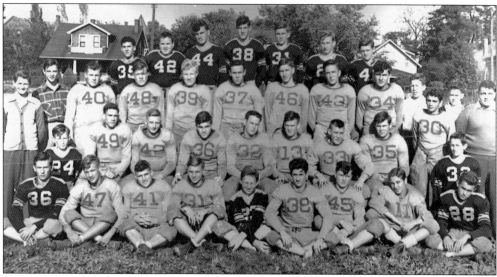

FIRST GRADUATING CLASS. Pictured is the first graduating class of Page-Jackson High School, the first African-American high school in Jefferson County. The graduates are, from left to right, (front row) Emma McCarm, Bertha Fox, Christine Spriggs, Beatrice Russ, and Mrs. Goldye Johnson, class sponsor; (back row) Raymond Brooks, Katherine Shelton, Lester Taylor, Dorothy Moats, Theodosia Lewis, and Nannie Fox. The freshmen class in 1938 had 30 students, but only 10 graduated on May 27, 1942. In 1951, the school was relocated to Mordington Avenue. (Courtesy of collection of James Taylor, Charles Town, WV.)

TOWN HIGH SCHOOL FOOTBALL. In this 1940s photo the Charles Town High School football team includes #38 Fred Propps, #48 Logan Lynch, #39 Charles Gore, and #47 Henry Davenport. There appear to be 5 coaches and 32 members of the team. Those wearing light jerseys might be varsity and the dark jerseys might be junior varsity, but that is uncertain. (Courtesy of collection of Bill Theriault, Bakerton, WV.)

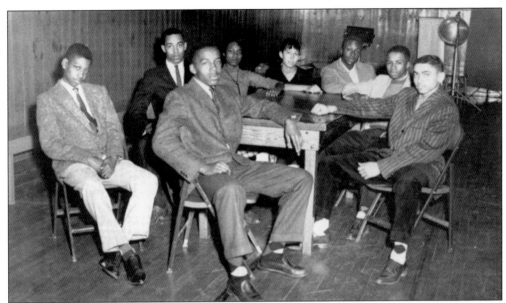

STUDENT COUNCIL. Pictured is the Student Council at Page-Jackson High School. This photo was taken in the early 1950s. Starting at the extreme left and going clockwise around the table are Phillip Braxton, Kirk Baylor, Emma Butler, Betty Sims, George Dozier, George Mitchell, Paul Sims, and Maurice Braxton. Identification of the students is courtesy of Barry Burns, Frederick, Maryland. (Courtesy of collection of James Taylor, Charles Town, WV.)

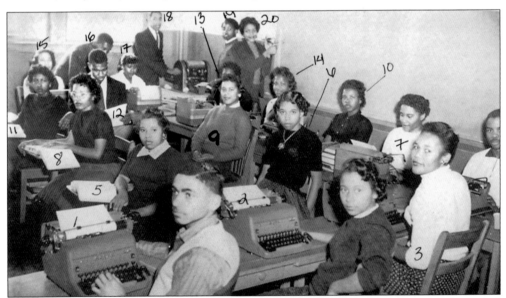

TYPING CLASS. These students from the 1950s are learning the use of office machines. Identified by numbers are (1) Paul Sims, (2) Morrisey Rutherford, (3) Rosa Green, (4) Norvel Willis, (5) Sylvia Stanton, (6) Ardalia Johnson, (7) Rosa Green, (8) Brenda Hughes, (9) Gean Lee, (10) Margaret Ransuer, (11) Frances Dotson, (12) Steven Luckett, (13) ? Raymonda Williams, (14) Viola Bailey, (15) Mildred Garner, (16) Marice Braxton, (17) Mary Galloway, (18) Kirk Baylor, (19) Brances Payton, and (20) Brenda Washington. (Courtesy of collection of James Taylor, WV.)

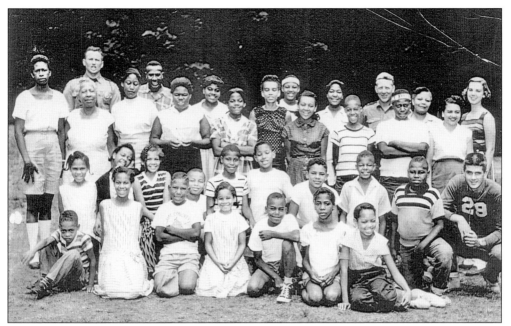

AFRICAN-AMERICAN STUDENTS AT 4-H CAMP. In this 1950s photo a large group of students take a break from their 4-H Camp activities to have their photo snapped. The 4-H Club is a program for children from age 5 to 21 (age depends on which state the program is in) that enables them to meet new people, learn new life skills and responsibility, and set and achieve goals, all while having fun. (Courtesy of collection of James Taylor, Charles Town, WV.)

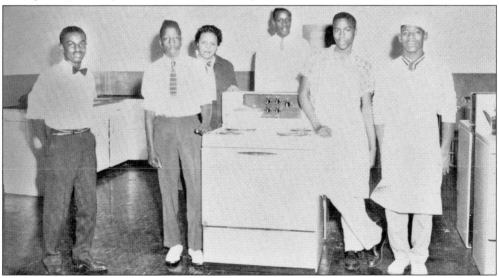

HOME ECONOMICS CLASS. In this 1950s photo students pictured in home economics are, from left to right, James Twyman, Henry Paige, Mrs. Lewis (teacher), Venning Johnson, Daniel Jackson, and Randolph Doleman. In home economics class, students learned how to cook, sew flat items, mend clothes, plan a menu, and budget finances. Today, schools call it "bachelor living" to attract male students. In times past, it was often required by both sexes at the junior high level and often considered an elective at the high school level. (Courtesy of collection of James Taylor, Charles Town, WV.)

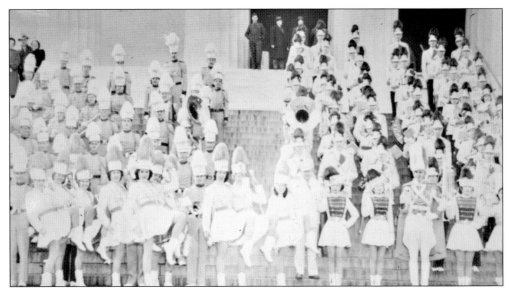

MARCHING BANDS. Taken February 5, 1953 on the steps of the Lincoln Memorial, Charles Town High School Band is on the left, and Hagerstown High School Band is on the right. Jefferson County Schools finally de-segregated in 1966 when they were ordered to do so or face the loss of $50,000 in federal funds. Schools benefited from de-segregation countrywide. (Courtesy of collection of Bill Theriault, Bakerton, WV.)

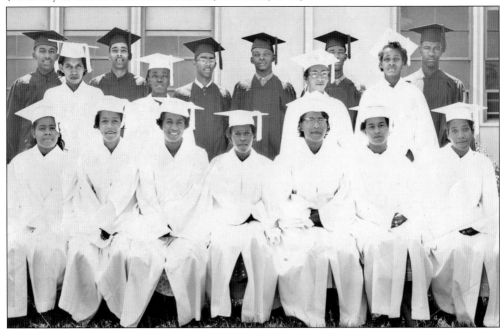

GRADUATION, 1958. The 1958 graduation class of Page-Jackson High School has 17 proud and happy members; they are, from left to right, (front row) Mary Galloway, Brenda Washington, Franciene Russ, Anna Washington, Violet Morris, Jean Lee, and Frances Gray; (middle row) Ardalia Johnson, Anna Mae Jenkins, Andrey Twyman, and Frances Payton; (back row) Maurice Braxton, Kirk Baylor, Barry Burns, William Woodfork, Charles Branson, and Stephen Luckett. Identification was provided by Barry Burns. (Courtesy of Barry Burns, Frederick, MD.)

Six

MILITARY SERVICE

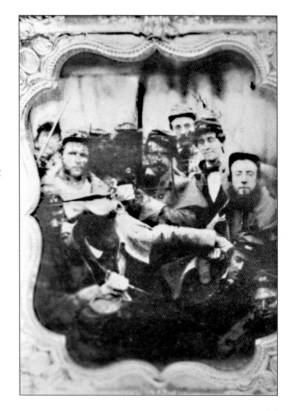

FIRST VIRGINIA REGIMENT. This regiment had been sent by Gov. Henry A. Wise to keep the peace during the trial and execution of John Brown. Other companies stationed in Charles Town during the trial included Wheeling State Fencibles, Petersburg Grays, Alexandria Artillery, Mt. Vernon Guards, Morgan Continentals, Richmond Howitzers, Petersburg Artillery, Upper Fauquier Cavalry, Lower Fauquier Cavalry, Wheeling Rifles, Virginia Rifles, Petersburg Guards, Alexandria Riflemen, and the cadets of Virginia Military Institute. (Courtesy of collection of Bill Theriault, Bakerton, WV.)

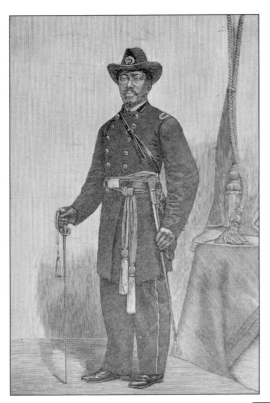

MARTIN ROBISON DELANY. Martin Delany was born in Charles Town on May 6, 1812, one of five children. His parents relocated to Chambersburg, Pennsylvania, after they were persecuted for teaching their children to read and write. He was a doctor and after a meeting with Lincoln became the first black officer in the Civil War. (Courtesy of *Black Phalanx: A History of the United States in the Wars of 1775–1812, 1861–1865*; The Ohio Historical Society.)

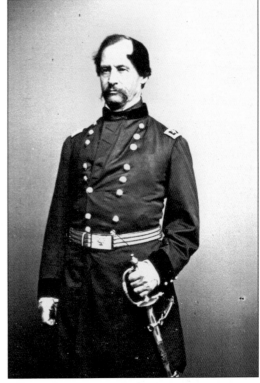

MAJ. GEN. DAVID HUNTER. David and Andrew Hunter were first cousins and were close as children, and David had given Andrew a gold ring as a sign of his affection. David served with the Union, and on a raid in Virginia, he burned the Virginia Military Institute. He burned Andrew's home and outbuildings, and the Union cavalry camped on Andrew's property. David also burned Bedford, the home of Col. Edmund J. Lee. (Courtesy of the Library of Congress, LC-B814-1820, digital ID cwpb 04526.)

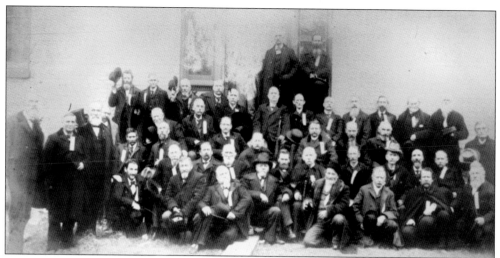

CONFEDERATE VETERANS REUNION. Pictured here are veterans of the Confederate States of America. This photo was taken in Middleway in front of the old Union Church. Although the exact date of the photo is unknown, it was probably approximately 40 to 50 years after the Civil War, based on the apparent ages of the veterans. Most men in Jefferson County enlisted in the Confederacy—there is no record of any Union companies. (Courtesy of collection of Bill Theriault, Bakerton, WV.)

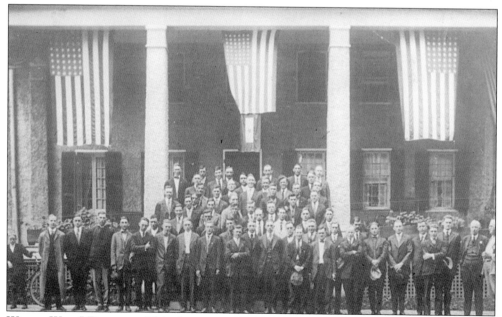

WORLD WAR I DRAFTEES. This photo was taken June 26, 1918, in front of the Getzendanner House on E. Washington Street. The World War I draftees are waiting formal induction. On May 28, 1917, Congress passed the Selective Service Act, requiring all males age 21 to 31 to register. There were 1,129 men in Jefferson County who qualified—78 percent white and 22 percent African American. A total of 128 Jefferson County African Americans fought in World War I, and eight of those lost their lives. (Courtesy of collection of Bill Theriault, Bakerton, WV.)

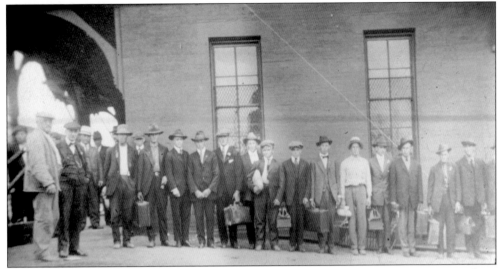

WORLD WAR I INDUCTEES. This undated photo shows World War I inductees standing in front of the Charles Town railroad station. The first number drawn in the national lottery belonged to Harry T. Underwood of Middleway, West Virginia, outside of Charles Town. The second number drawn also belonged to a Jefferson County man, Hugh S. Moler of Engle. Of the 548 men from Jefferson County who served, 30 died. (Courtesy of collection of Bill Theriault, Bakerton, WV.)

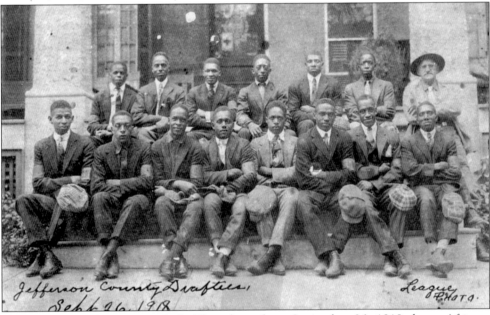

WORLD WAR I DRAFTEES, 1918. This photo from September 26, 1918 shows African-American draftees from Jefferson County. There were 314 African Americans registered in Jefferson County. Of the 128 who went to war, eight lost their lives. Solomon Johnson was the only one killed in battle. Natural causes claimed Martin Snyder overseas; and Barbour Boggerson, George Carr, Jesse Price, Luther Robinson, William W. Summers, and James Thornton died from diseases in hospitals stateside. (Courtesy of collection of James Taylor, Charles Town, WV.)

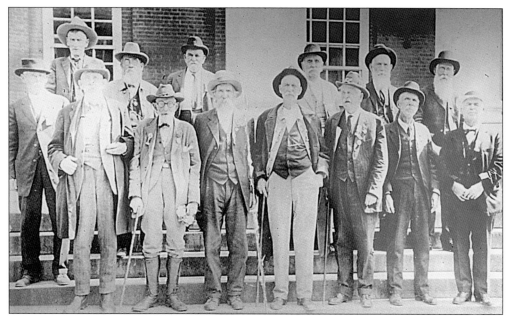

FIRST VIRGINIA CAVALRY. Veterans of the First Virginia Cavalry gather in the early 1920s. Francis Jones, second from left in front, passed away on October 6, 1924. Jefferson County was overwhelming Southern in its sentiments. The county contributed approximately 1,600 men in 10 different companies. The Union Army has no record of any groups from Jefferson County. (Courtesy of collection of Bill Theriault, Bakerton, WV.)

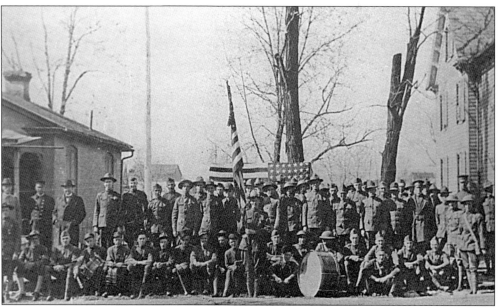

VETERANS IN UNIFORM. In this *c.* 1920 photo, uniformed veterans stand in front of the American Legion Home. On September 25, 1919, a parade welcomed the soldiers home. Grateful citizens came out in large numbers to show appreciation for the service of the veterans. After the parade, there were athletic events and dancing, after which the soldiers were treated to a lunch made by local ladies. (Courtesy of collection of Bill Theriault, Bakerton, WV.)

JAMES PENDLETON. Pendleton sits proudly in his uniform. The uniforms on these two pages are all different. Different branches of the services have had distinctive uniforms that have evolved over the years. As permanent military units evolved, special uniforms for them evolved also. These were usually identifying uniforms. Countries would select characteristics to display on their uniforms that would identify them. (Courtesy of collection of James Taylor, Charles Town, WV.)

EDWARD TOLBERT. Tolbert stands seriously and proudly wearing his uniform. Elite corps were often identified by special accessories for their uniforms, such as the Green Berets. Often the change in a uniform or hat style was necessitated by functionality. When the cocked hat was replaced with a stocking cap, it was because the cocked hat got in the way when service men would sling their muskets over their shoulders. (Courtesy of collection of James Taylor, Charles Town, WV.)

AUGUSTUS DEHURTBURN THORNTON.
Thornton displays his at-ease stance with
a mock weapon. Many of the changes to
the uniform styles have been necessitated
by the environment. In general, leaders want
the clothing to be functional and
not to interfere with the service men
and women performing their duties.
(Courtesy of collection of James Taylor,
Charles Town, WV.)

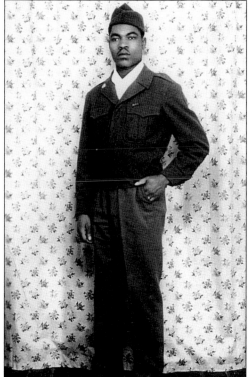

CHARLES SONNY BURNETT. Burnett models
his uniform, wearing the jacket made popular
by President Eisenhower in World War II.
Very often specific units relied on insignia
to distinguish themselves, although those
distinctions were officially discouraged.
As military forces continue to be needed,
changes to those uniforms will continue to
evolve. As fabrics are improved, they will
be adopted for use in the military units.
(Courtesy of collection of James Taylor,
Charles Town, WV)

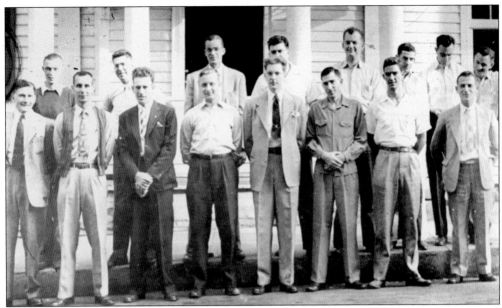

WORLD WAR II INDUCTEES. Inductees stand in front of the Mason Building in Charles Town. On September 14, 1939, Congress passed a peacetime Selective Service Act. On October 16, 2,010 young men ages 21 to 36 registered. Again, Jefferson County had the first man drafted in Lester L. Bush. Second was Edward Clarence Cummings of Harpers Ferry. Local physicians helped with the physical exams. (Courtesy of collection of Bill Theriault, Bakerton, WV.)

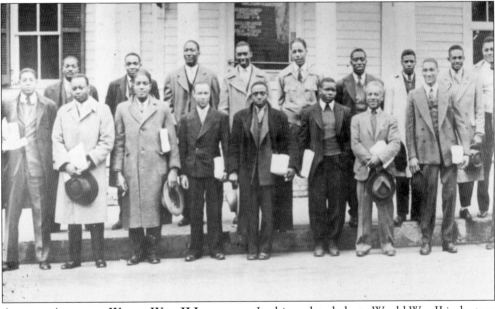

AFRICAN-AMERICAN WORLD WAR II INDUCTEES. In this undated photo World War II inductees stand in front of the Mason Building. Jefferson County contributed 4,208 registrants. Of the total, 1,447 were drafted. Luther Edgar Lanham of Charles Town volunteered in November 1940. Coincidentally, in April 1946 Clarence Philip Moler, the last man to be inducted was also a volunteer. During World War II, the troops continued to serve in segregated units. (Courtesy of collection of Bill Theriault, Bakerton, WV.)

WORLD WAR II INDUCTEES. Inductees are shown in front of the Mason Building on February 2, 1943. They are, from left to right, Paul J. Corso, Harvey E. Harding, Harwood E. Potts, Richard Orndorff, Harry R. Tharpe Jr., and Charles W. Hostler. These men were sent to Fort Hayes, Ohio. The draft was not suspended until October 1946. The first casualty of the war was Pvt. Henry Leight from Leetown. (Courtesy of collection of Bill Theriault, Bakerton, WV.)

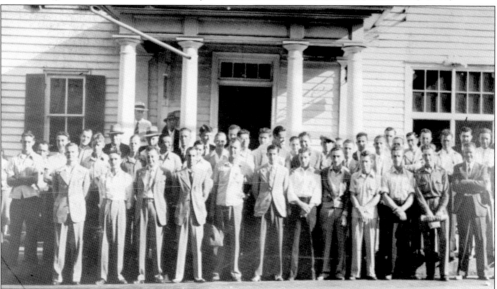

WORLD WAR II INDUCTEES. Of all the Jefferson County "obligated volunteers," 46 would not return alive. Causes of death were varied—killed in action, died from wounds, died from diseases, killed by accident, or they simply did not return from routine missions. Women also served in World War II, but they were truly volunteers, as women were not drafted. The first woman doctor in the army had spent her childhood in Charles Town. (Courtesy of collection of Bill Theriault, Bakerton, WV.)

TWO SOLDIERS, READY TO SERVE.
William Terry and Doug Taylor
smile for the camera as they prepare
to serve their country. As was the
case of all servicemen, these men
put their personal lives on hold
to serve their country. During the
course of the war, the United States
lost a total of 407,318 lives—of
those, 292,131 were battle deaths
and the remainder was from other
causes. (Courtesy of collection of
James Taylor, Charles Town, WV.)

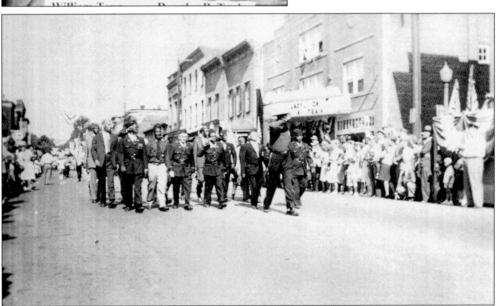

PARADE OF WORLD WAR II VETERANS. In this 1946 photo, African-American World War II
veterans are honored. One of the rewards that the servicemen received from the government
was the G.I. Bill, giving servicemen the opportunity to get the education that they missed while
serving their country. Many servicemen took advantage of this opportunity, and they still do
today. (Courtesy of collection of James Taylor, Charles Town, WV.)

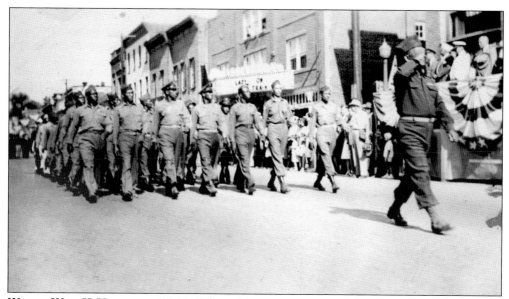

WORLD WAR II VETERANS, 1946. When the war was over and the service men and women came home, America celebrated their return. In this parade African-American veterans proudly march in a welcome-home parade. These veterans were pleased to return, as there were 407,318 who did not return alive. Honoring the veterans is the American thing to do, and the citizens of Jefferson County rose to the occasion. (Courtesy of collection of James Taylor, Charles Town, WV.)

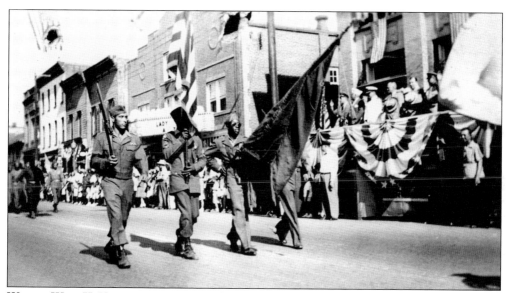

WORLD WAR II VETERANS, 1946. In this photo, World War II veterans display the colors as they march in a welcome-home parade. As they pass the viewing stand, crowds welcome them home with abundant thanks for their dedicated service. Even though the African-American servicemen were discriminated against throughout their service time, they served their country bravely. Those discriminating treatments would gradually be eliminated as segregation was phased out throughout the country. (Courtesy of collection of James Taylor, Charles Town, WV.)

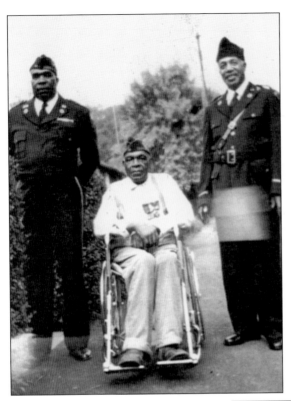

MEMORIAL DAY, 1952. This photo was taken on Memorial Day, 1952. The veterans pictured are, from left to right, Edward, David, and Mark Carey. They wear their uniforms with pride, as well they should; they served their country in grand fashion at a time that they were very much needed. Jefferson County contributed 548 men to military service. Of those, 30 did not return home alive. Their sacrifice will not be forgotten. (Courtesy of collection of James Taylor, Charles Town, WV.)

JOHN FERGUSON, VETERAN. The smile on this veteran's face says it all—he served his country proudly and can rest on his laurels. African Americans served their country under adverse conditions, with discrimination and segregation rampant in the services. They proudly overcame obstacles and achieved beyond the country's wildest expectations. John Ferguson, you were a hero! (Courtesy of collection of James Taylor, Charles Town, WV.)

Seven

IMPORTANT BUILDINGS, ORGANIZATIONS, *and* PEOPLE

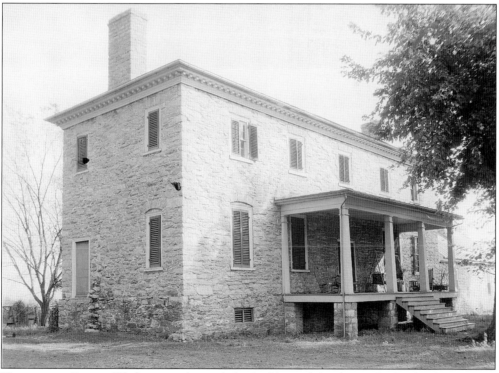

HAREWOOD. George Washington directed the building of this house for his brother Samuel sometime between 1756 and 1770. It is one of the earliest limestone structures in the valley. Shirley Smith was paid one acre of land per team per day for hauling limestone from a nearby quarry. Black walnut, abundant in the vicinity, was used for the windowsills. Samuel acquired a total of 4,000 acres, most of it in Jefferson County. (Courtesy of Library of Congress, HABS, WVA,19-CHART.V,1-1.)

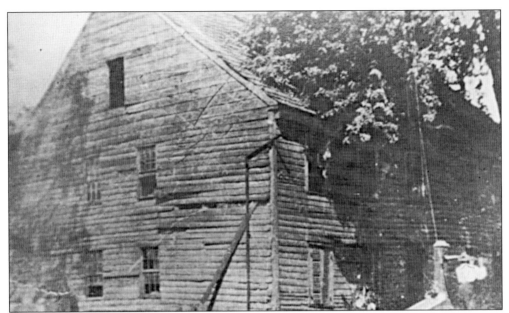

HOLL'S TAVERN. Holl's Tavern was on the north side of W. Washington Street on the east bank of Evitt's Run in Charles Town. Eventually, the tavern was razed, and the former site is now part of Evitt's Run Park. After coming here from Holland, Mr. and Mrs. Samuel Holl reportedly beautified the location with flowers from their native land. The pump out front was built in 1807 and provided water for horses. (Courtesy of collection of Bill Theriault, Bakerton, WV.)

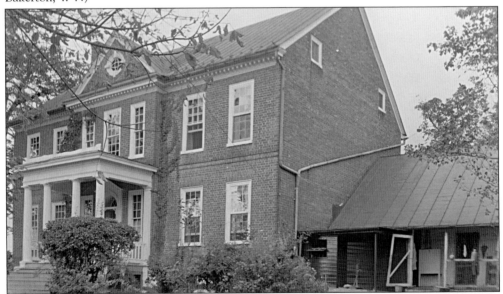

PIEDMONT. In the decade after 1730, a member of the Society of Friends, Robert Worthington Sr., acquired 3,000 acres and established his home on Evitt's Marsh. He built the stone part of the house around 1735 and named it after his home in England, Quarry Marsh. At one time, a mill was located on the Piedmont property. On the interior, some of the walls were originally covered with paper brought from Paris. (Courtesy of the Library of Congress, HABS, WVA,19-CHART.V,10-1.)

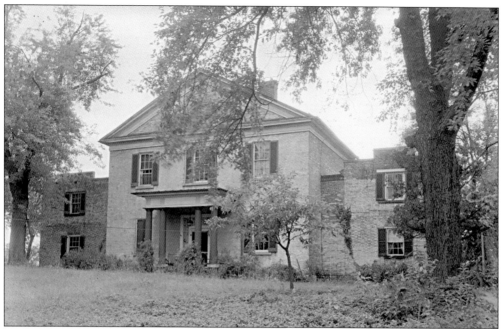

HAPPY RETREAT. Charles Washington came from Spotsylvania County and built Happy Retreat in 1780 on the edge of Charles Town. He built two brick wings connected by a breezeway. George Washington visited his brother Charles at Happy Retreat many times. In 1837, Judge Isaac Douglass purchased the home, built the central portion, and renamed it Mordington, after the Douglass ancestral home in Scotland. (Courtesy of Library of Congress, HABS, WVA,19-CHART,5-1.)

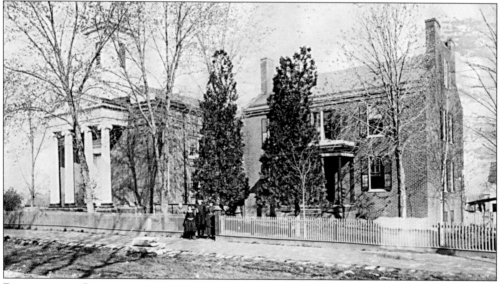

PRESBYTERIAN CHURCH AND MANSE. Located on present day E. Washington Street, the church faces south. This church, the third built to serve the congregation, was built in 1851. In 1787, a deed signed by Charles and Mildred Washington conveyed the lot on the corner of Congress and West Streets, and the first church was built. That document hangs in the vestibule of the church. (Courtesy of Jefferson County Museum, Charles Town, WV.)

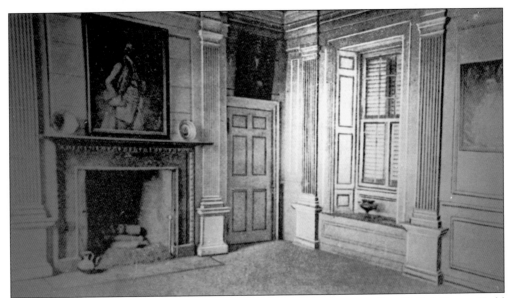

WEDDING AT HAREWOOD. The wedding of Dolley (some sources spell it Dolly) Payne Todd and James Madison took place on September 15, 1794 in this drawing room. The Reverend Alexander Balmaine, a relative of Madison's from Winchester, Virginia, officiated. Dolley's sister Lucy married George Steptoe Washington, one of Samuel Washington's sons. Harewood's owner George Steptoe Washington, son of Samuel Washington, was married to Dolley's sister, Lucy. The house's marble mantle was given to George Washington by the Marquis de Lafayette, and the stairway was one solid piece brought from England. (Courtesy of collection of Bill Theriault, Bakerton, WV.)

WASHINGTON GRAVES. The graves of Charles Washington and his wife Mildred Thornton. are located on land that was part of the original estate. More Washington family members than anywhere else in the country—more than 70—are buried in the Zion Episcopal Church in Charles Town. The photo is by Edwin Fitzpatrick. (Courtesy of collection of Bill Theriault, Bakerton, WV.)

WASHINGTON MOURNING LOCKET OR PIN. Pictured is a Washington family mourning locket or pin from Lester Alexander. Mourning jewelry became popular in 15th- and 16th-century England, although it had been around since the Middle Ages. Often locks of the deceased's hair were incorporated into the pieces, and specific details about the deceased's name, age, birthday, and death were included. The traditional mourning stone was jet. (Courtesy of collection of Bill Theriault, Bakerton, WV.)

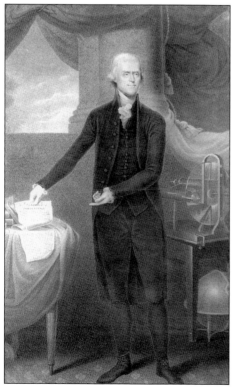

THOMAS JEFFERSON. Thomas Jefferson was vice president of the United States and President-elect when Jefferson County was created. On January 9, 1801, the Virginia General Assembly passed an act to divide Berkeley County, with the new county to be named in honor of Thomas Jefferson. On October 26, 1801, the division took place, with the first sheriff being James Monroe. (Photo from *Portraits of the Presidents and First Ladies, 1789–Present*, Library of Congress, digital ID's cph 3b22585 and cph 3a10227.)

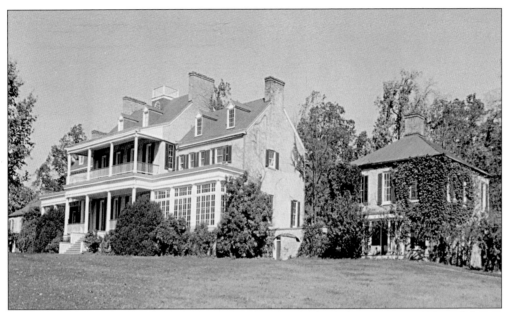

CLAYMONT COURT. Bushrod Corbin Washington moved to the area in 1820 and began construction of his home, Claymont Court, at about the same time. Bushrod, a great-nephew of President Washington, married Anna Blackburn. In 1838 the house caught fire, and the mansion was reduced to ashes. The loss was estimated to be $30,000, but Bushrod rebuilt Claymont Court. During the Civil War, many Washington family members sought refuge here as hostilities raged elsewhere. (Courtesy of Library of Congress, HABS, WVA,19-CHART.V,3-1.)

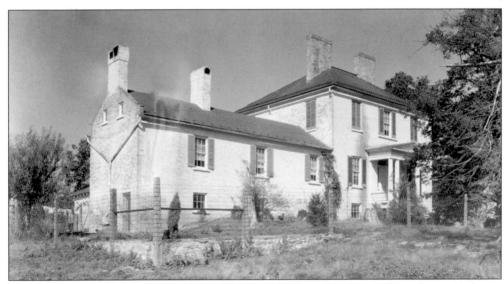

CEDAR LAWN. Cedar Lawn, originally called Berry Hill, was built in 1825 and was the home of Samuel Washington's grandson John Thornton Augustine Washington. John was born on January 22, 1826. After graduating from Princeton, John entered West Point and graduated in 1849. John was chief of staff for Robert E. Lee. He died on July 10, 1894, in Washington, D.C. Cedar Lawn is a two-story brick house with a one and one-half story wing. The original house was destroyed by fire. (Courtesy of Library of Congress, HABS, WVA,19-CHART.V,5-1.)

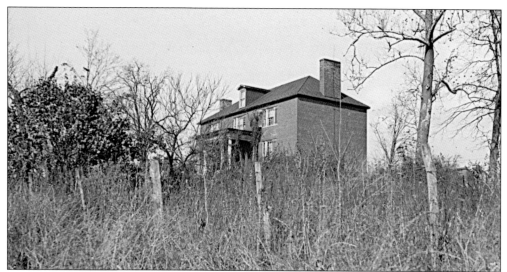

LOCUST HILL. Locust Hill was the home of John Ariss. He designed several famous mansions including Kenmore in Fredericksburg, Harewood in Jefferson County, Blandfield in Essex County, Fairfield in Clarke County, Mount Airy in Richmond County, and Locust Hill. During the 1864 Shenandoah Valley Campaign, the center of Sheridan's lines was at Locust Hill, which Sheridan used as his headquarters. The house was originally built by Lucy Elizabeth, great granddaughter of Samuel Washington. (Courtesy of Library of Congress, HABS, WVA,19-CHART.V,12-1.)

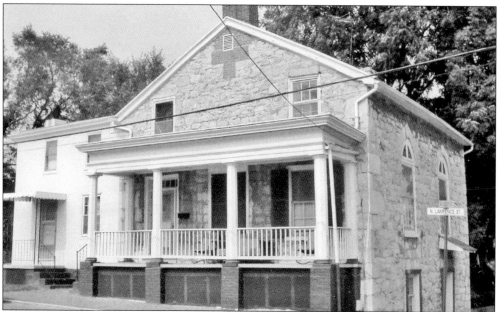

EPISCOPAL READING ROOM. This building housed the Episcopal Lecture Room in 1859. It was built between 1833 and 1839. In 1859, John Wilkes Booth came to town as a member of the Richmond Grays to witness the hanging of John Brown. During his stay in Charles Town he gave dramatic readings in the Episcopal Lecturing Reading Room for local townspeople. When he returned home after the trial, he also quit the Richmond Grays, for they had served his purpose. (Photo by Dolly Nasby.)

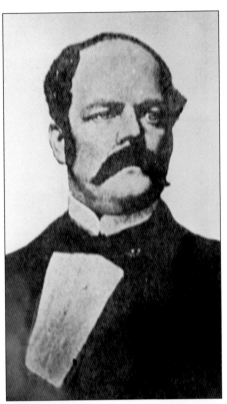

Col. Lewis W. Washington. One of John Brown's prisoners during the raid on Harpers Ferry, Col. Lewis W. Washington, was an eminent gentleman farmer and slaveholder in Jefferson County. Colonel Washington was a great grandnephew of George Washington. Brown had captured Colonel Washington, along with others, in hopes of gaining some bargaining power, but to no avail. The hostages were all eventually rescued, and fortunately none of the hostages were harmed. (Courtesy of collection of Bill Theriault, Bakerton, WV.)

Capt. John Avis's House. Shown is the house of Capt. John Avis, John Brown's jailer in 1859. Avis's daughter, Mrs. Elizabeth Darlington, stands on the porch. Avis served in the Mexican-American War and in the Civil War. At varying times in his life, he served Charles Town as mayor, superintendent of the county almshouse, and justice of the peace. When the Charles Town High School needed more space, the house was razed. (Courtesy of collection of Bill Theriault, Bakerton, WV.)

SHERIDAN AND GRANT MEET. This house on E. Washington Street became known as the Rutherford House. The Rutherfords hosted the meeting between Gen. Phillip Sheridan and Gen. U.S. Grant on September 17, 1864, to discuss war strategies. It was later converted into a bed and breakfast and became known as The Carriage Inn. (Courtesy of collection of Bill Theriault, Bakerton, WV.)

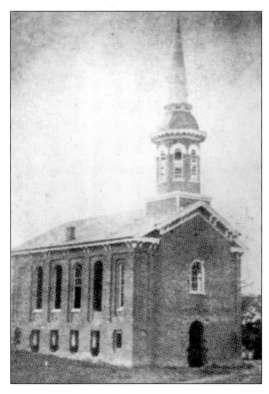

CHARLES TOWN BAPTIST CHURCH. This c. 1865 photo shows the Charles Town Baptist Church at the end of the Civil War. The building began in 1859. At the time that the workmen were installing the roof, the John Brown hanging was taking place, and the workmen were able to witness the execution from their vantage point. Yankee troops took over the structure and used the lower portion as a stable. (Courtesy of collection of Bill Theriault, Bakerton, WV.)

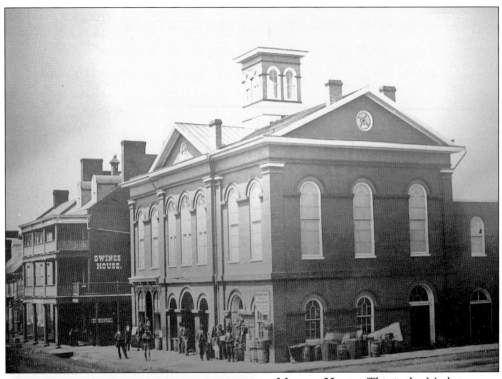

MARKET HOUSE. This is the Market House building in 1875, located on the northwest corner of George and Washington Streets. This building has been used in many capacities since it was built. In this photo, the sign on the corner reads "Roderick & Bros. Family Groceries, Provisions, Tobacco & Cigars." The Owings House, to the left, bears a sign that reads "Bar Below." (Courtesy of collection of Bill Theriault, Bakerton, WV.)

ROGER PRESTON CHEW. Roger Preston Chew (front row, left) and his wife (front row, middle) are pictured here. Chew was born April 9, 1843, in Loudoun County, Virginia. His family moved to Jefferson County in 1846. He joined the Confederate Army and organized Chew's Battery. When the war was over, Chew returned to Jefferson County. He married Louise Fontaine Washington, daughter of Col. John Augustine Washington, in 1871. From 1884 to 1890 he served as a state representative. (Courtesy of Jefferson County Museum, Charles Town, WV.)

WRIGHT DENNY HOUSE. This 1958 photo shows the Wright Denny House with G.L. Hoffman and a child in the foreground. Wright Denny was an accomplished educator in Charles Town. In the fall of 1893, he was appointed the head of the Charles Town Graded School, where he served until his retirement in 1939. Principal Denny exerted tremendous influence, and the county named an elementary school in honor of his hard work. (Courtesy of collection of Bill Theriault, Bakerton, WV.)

WILLIAM L. WILSON HOUSE. This is the home of William Lyne Wilson, the first postmaster general to implement a rural free delivery. He served in the second administration of President Grover Cleveland. The delivery involved five carriers—one for Uvilla, one for Halltown, and three for Charles Town. Each carrier rode approximately 20 miles on horseback. At one time, the position of postmaster general was a cabinet level position. (Courtesy of Jefferson County Museum, Charles Town, WV.)

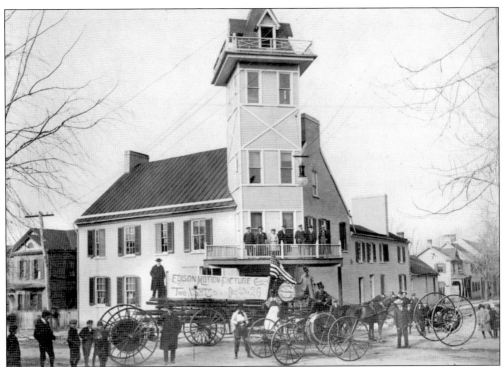

CITIZEN'S FIRE HALL, CHARLES TOWN. Pictured in this undated photo is the Citizen's Fire Hall. It was situated on the northwest corner of W. West Washington Street and West Street. It was almost 100 years after the town was incorporated before a fire department was organized on June 22, 1895. The certificate of incorporation was signed by the clerk of the court of Jefferson County, W.F. Alexander. (Courtesy of collection of Bill Theriault, Bakerton, WV.)

C.W. BROWN, JEWELER. The storefront of C.W. Brown was located next to Brown's Ice Cream Parlor. Notice that on the front of the store, below the right window, the sign states that C.W. Brown was also an optician. Many years later that site would be the home of Western Auto. The photo is by Edwin Fitzpatrick. (Courtesy of collection of Bill Theriault, Bakerton, WV.)

CHARLES TOWN COURTHOUSE. This 1909 postcard is the only known instance of trim painted darker than the other surfaces. Charles Town Courthouse sits on one of the lots set aside by Charles Washington for community use. The brick Georgian colonial building was constructed in 1801 by an unknown builder. It was heavily damaged during the Civil War, and in 1872 the county seat was moved to Shepherdstown. After it was restored the seat returned to Charles Town. (Courtesy of collection of Bill Theriault, Bakerton, WV.)

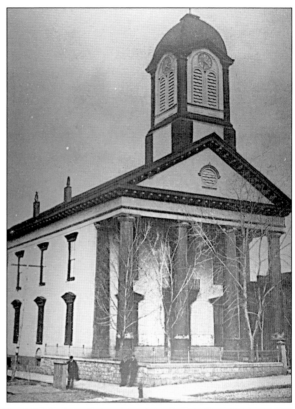

RANSON HOUSE. The town of Ranson was named for Matthew Ranson, who built the Ranson homestead pictured in this photo. The idea of a subdivision of Charles Town had been proposed by Roger Preston Chew when he served as head of the Charles Town Mining, Manufacturing, and Improvement Company. (Courtesy of Jefferson County Museum, Charles Town, WV.)

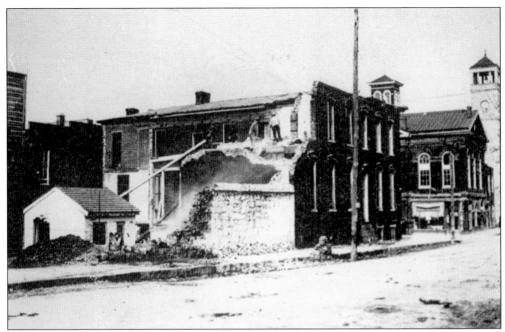

JAIL BEING RAZED. The old Charles Town Jail was razed in 1919. The destruction of the jail took place by hand, not big machines. Market House and Rouss Hall are in the background. The jail—now the post office—occupied one of the four corner lots which Charles Town founder Charles Washington set aside for community use. (Courtesy of Jefferson County Museum, Charles Town, WV.)

LITTLE CATHOLIC CHAPEL. This photo was taken in the 1930s. This chapel served both Catholics and Protestants in Millville, near Charles Town. From the 1930s through the late 1950s, between 75 and 100 people gathered here to worship regularly, starting with Sunday School, followed by a Catholic Mass. During this same period, a summer camp was held by the Marist Brothers from the Marist College near Silver Spring, Maryland. (Courtesy of collection of Bill Theriault, Bakerton, WV.)

Eight

TRANSPORTATION *and* COMMUNICATION

LIVERY STABLE. In this undated photo, an employee of a livery stable holds two horses by their halters. The livery stable was located at the corner of Congress and George Streets. If you were a visitor to the town, you could board your horses at the livery stable. If you needed to hire a horse for the day. that could be done also. (Courtesy of collection of Bill Theriault, Bakerton, WV.)

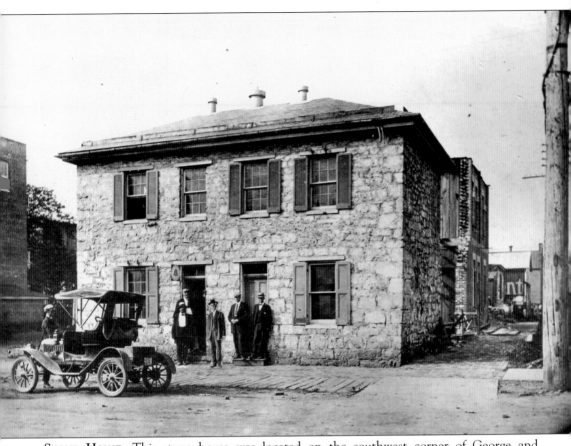

STONE HOUSE. This stone house was located on the southwest corner of George and Washington Streets. The building was used as the telephone company building in Charles Town. The first telephone in the county was installed in the office of the *Shepherdstown Register* on December 14, 1898, by Maryland Telephone Company. (Courtesy of collection of Bill Theriault, Bakerton, WV.)

POSTMASTER WILSON. William Lyne Wilson was postmaster general under President Grover Cleveland in 1896. Wilson conducted the nation's first trial of free mail delivery in Jefferson County on October 1, 1896. The route ran between Charles Town, Uvilla, and Halltown. At one time, the position of postmaster general was a cabinet level position. Today, the postal service is in the executive branch of the federal government but operates as an independent agency. (Courtesy of collection of Bill Theriault, Bakerton, WV.)

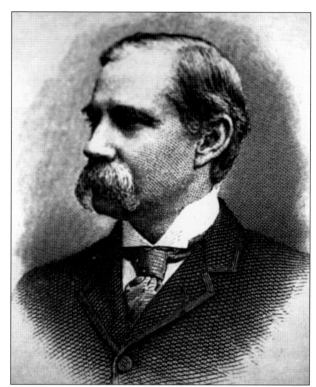

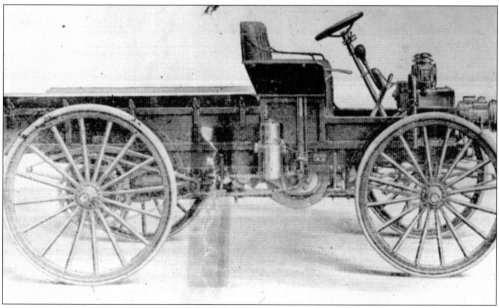

AUTO WAGON. This photo was taken between 1907 and 1910. It shows E.L. Wilson's International "Auto Wagon." E.L. Wilson's daughter Edna Wilson Hamm vividly remembers how she had to chew a six-inch stick of penny gum, which she stated was like chewing putty. After the chewing, the gum had to be applied to an apparatus at the side of the auto-wagon in order to operate the lights. Modern conveniences at their best! (Courtesy of collection of Bill Theriault, Bakerton, WV.)

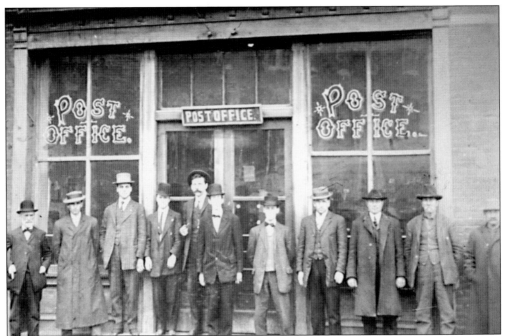

CHARLES TOWN POST OFFICE. When this photo was taken on December 10, 1908, the post office was located in Charles Washington Hall. Postmaster Henry Nathaniel Bradley is pictured in the center. Today more than 160 billion pieces of mail are handled by the Postal Service every year. (Courtesy of collection of Bill Theriault, Bakerton, WV.)

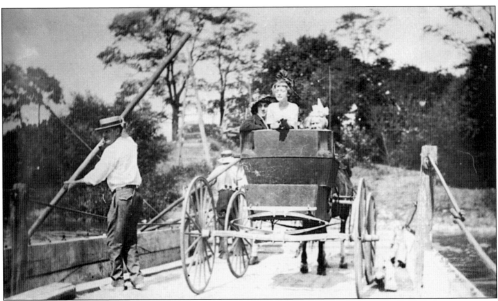

SHANNONDALE FERRY. This 1912 photo shows a ferry crossing the Shenandoah River. Willy Morgan helps the ferryman pole the boat. Seated in the buggy, from left to right, are Margaret Getzendanner, Florence Morgan, and Marie Morgan. A ferry service was usually available to cross rivers for a fee based on the size and weight of the vehicle being ferried across. (Courtesy of collection of Bill Theriault, Bakerton, WV.)

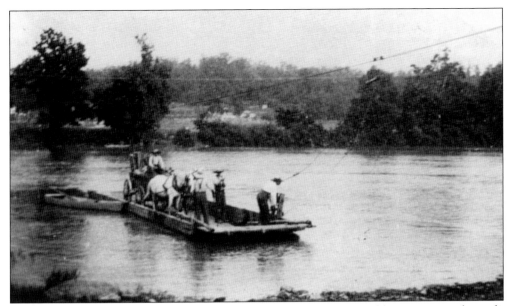

KEYE'S FERRY. In this photo a wagon can be seen on the ferry, in addition to several people standing. The driver of the wagon is sitting on the seat. Keye's Ferry was near the Millville region of Jefferson County. Many communities had to resort to crossing rivers by using ferries before dependable and sturdy bridges were constructed. (Courtesy of Jefferson County Museum, Charles Town, WV.)

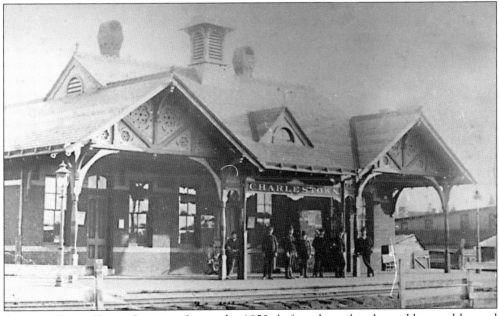

CHARLES TOWN TRAIN STATION. It was the 1850s before the railroads would extend beyond the mountains. Considered both a welcome convenience and a dreaded annoyance, when trains first arrived in communities people were wary. They were afraid that the sparks from the cars would hurt or kill their animals. Some people even thought that if you rode on a train over a certain speed, it would affect your brain. (Courtesy of collection of Bill Theriault, Bakerton, WV.)

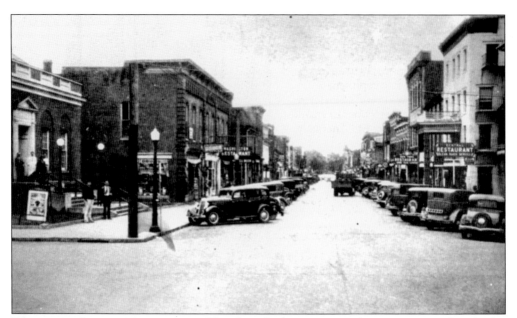

DOWNTOWN CHARLES TOWN, 1930s. This photo looks west on Washington Street. The Charles Town Post Office is on the far left. John S. Kelly, a postal employee, is standing in front of the building. Notice the streetlights, although no traffic signals are in evidence. The post office sits on the site of the old jail. (Courtesy of collection of Bill Theriault, Bakerton, WV.)

FORD AGENCY. Dan Yowell sits in his car in this 1948 photo. The photo was taken on the northeast corner of Liberty and Samuel Streets. The automobile industry was revolutionized when German engineer Gottlieb Daimler invented the internal-combustion engine. In America, Henry Ford produced his first car in 1893. In 1913, the introduction of the conveyor belt to the Ford factory greatly increased production. And the rest is history! (Courtesy of collection of Bill Theriault, Bakerton, WV.)

WESTERN UNION MESSENGER BOY. This photo shows messenger boy Edward Lee Pine seated on his bicycle. The Western Union shop was managed by Laurence Lloyd, *c.* 1929. The telegraph sent messages by way of wires and electricity. Was the telegraph a forerunner to email? (Courtesy of collection of Bill Theriault, Bakerton, WV.)

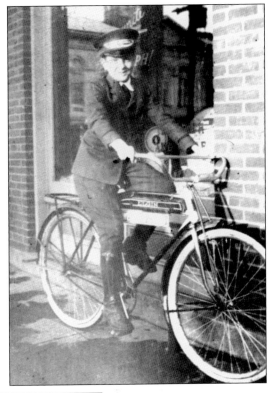

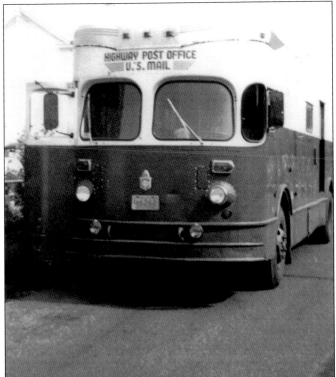

HIGHWAY POST OFFICE. Pictured here is what was referred to as a Highway Post Office. The bus was used to sort and deliver mail in the 1950s and 1960s. It was thought that buses would be cheaper and quicker than regular delivery. While a letter mailed in Charles Town would get to Richmond the same day, it was not cheaper, and it was discontinued because of the cost. (Courtesy of Tracey Miller, postmaster of the Charles Town Post Office, Charles Town, WV.)

VIRTS GARAGE. This 1940 photo shows the showroom of Virts Garage on W. Washington Street in Charles Town. On the left in the light suit is Mark B. Wetzel. R.L. Virts is in the center. The man to the right is unidentified. In 1920, only 1 in 13 people owned a car. In 1940, approximately 1 person in 4.79 owned a car. In 1950, 1 person in 3.74 owned a car. (Courtesy of collection of Bill Theriault, Bakerton, WV.)

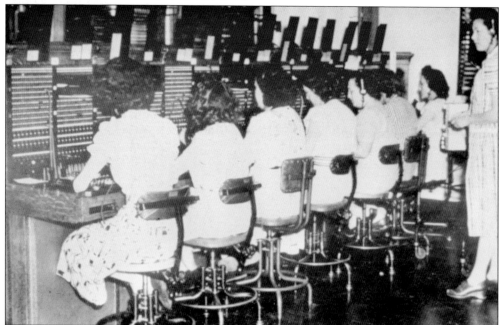

CENTRAL TELEPHONE SWITCHBOARD. Telephone operators work at the Central Telephone Switchboard in 1948. Service assistant Alice Collis stands at the right. All phone calls had to be routed through an operator. Instead of dialing a number, the caller would tell the operator who he/she wanted to reach, and the operator would connect the call. (Courtesy of collection of Bill Theriault, Bakerton, WV.)

Nine

MUSICALLY INCLINED

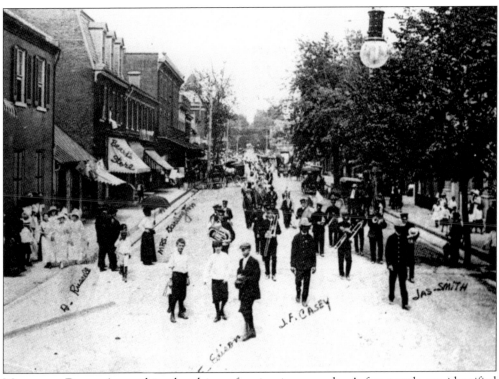

MARCHING BAND. A marching band is performing in a parade. A few people are identified directly on the photo. The teaching of music was not introduced into public schools until 1915, and not all schools offered the subject. Many students were taught by family members on whatever instruments were available. The photo was taken by Edwin Fitzpatrick. (Courtesy of collection of Bill Theriault, Bakerton, WV.)

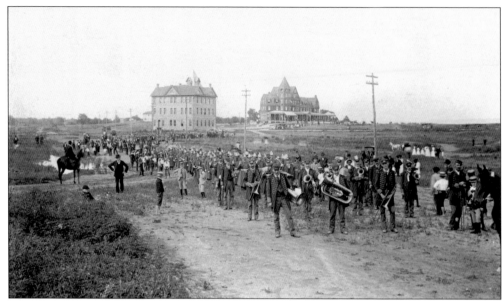

RANSON MARCHING BAND. The Ranson Marching Band is pictured here between 1890 and 1900. St. Hilda's Hall can be seen in the right rear of the photo. The town hall is visible to the left of St. Hilda's. Marching bands came to be established as distinct musical organizations in the 1800s. Sizes of bands vary greatly, with some reaching 300 or more members. (Courtesy of collection of Bill Theriault, Bakerton, WV.)

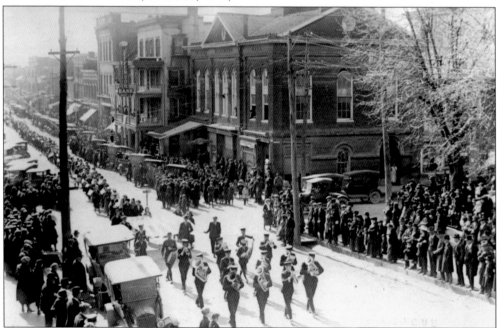

FIREMAN'S PARADE, 1906. The Harpers Ferry Band plays and marches in formation east on Washington Street just after crossing George Street. The exact occasion is unknown, but it seems to be a well-attended parade. Cars are parked along side the sidewalks to allow the parade to pass by. At least one spectator can be seen leaning out of a second-story window of the Market House. (Courtesy of Jefferson County Museum, Charles Town, WV.)

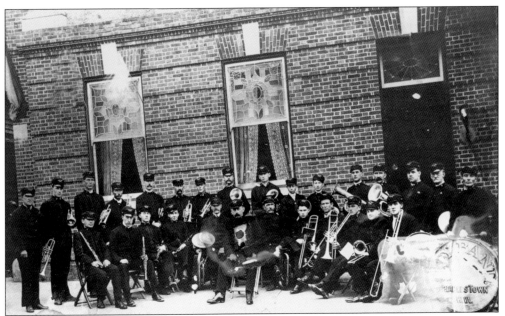

HENSON'S BAND. This photo was taken on October 30, 1908, in front of the Thomas Jefferson Hotel in Charles Town. The occasion was a big meeting of the Shriners. Third from the left, holding a clarinet, is P.O. Barr. The band was often called "Henson's Gang Band" and was organized by Mr. Henson. It performed in the Opera House, at church functions, and other events. (Courtesy of Jefferson County Museum, Charles Town, WV.)

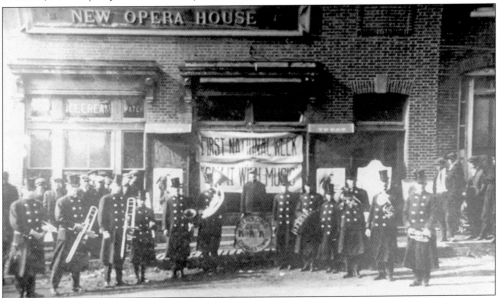

NEW OPERA HOUSE. This 1911 photo shows the New Opera House, today referred to as the Old Opera House. For approximately 30 years, E.G. Henson managed the Opera House. In one section, Chris Fridley operated a small soda and ice-cream store. The band was known as the Henson Gang Band. During intermissions at the Opera House, the audience was often treated to a song sung and played on the piano by Mr. Henson. (Courtesy of collection of Bill Theriault, Bakerton, WV.)

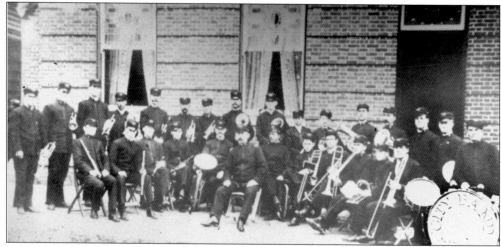

BAND OF CHARLES TOWN. The City Band of Charles Town, active from 1910 to 1914, was founded and directed by Tom Baker, seated front and center. Directly behind Baker is French horn player Mr. Willis. Other instrumentalists were, in no particular order, trombonists Ed Baker, Charlie Strider, Roger Manuel, Ebb Baker, and Spencer Marcus; coronetists Ed Henson and Pete Baker; French horn players Edgar Jones and Jim Painter; clarinetist Arch Mahoney; bass horn players Bob Apple and Phil Davis; bass drummer Shirley Hooe; snare drummer John Harold; baritone horn players Will "Buck" Larue and Roy Baker; trumpeters Cleveland Furr and Walter Glace; and cymbaleer Bob David. (Courtesy of collection of Bill Theriault, Bakerton, WV.)

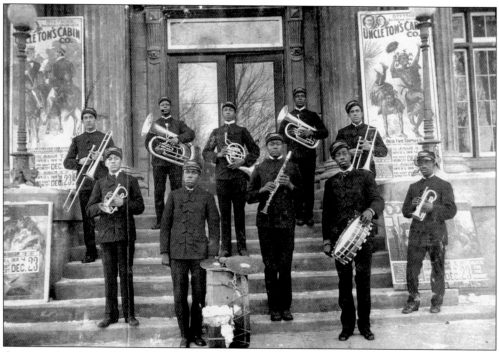

AFRICAN-AMERICAN BAND. This band probably performed in the early 1900s. Very likely these musicians were self-taught. The posters in the background are advertising a production of *Uncle Tom's Cabin*. (Courtesy of collection of James Taylor, Charles Town, WV.)

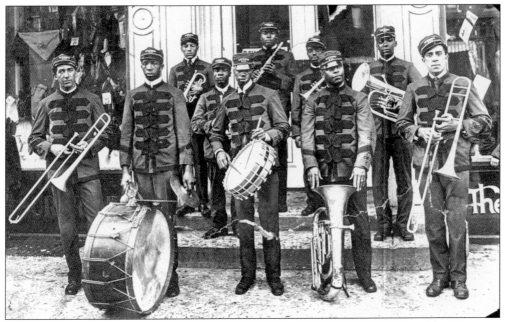

AFRICAN-AMERICAN BAND, 1920s. This band performed in Charles Town. One of the organizers was "Bunt" Jackson, on the right. Bands usually play mainly brass, woodwind, and percussion instruments. The formation of African-American bands depended on finances. In the case of this band, it not only could afford the instruments but also the uniforms, which said a lot for their dedication and devotion to music. (Courtesy of collection of James Taylor, Charles Town, WV.)

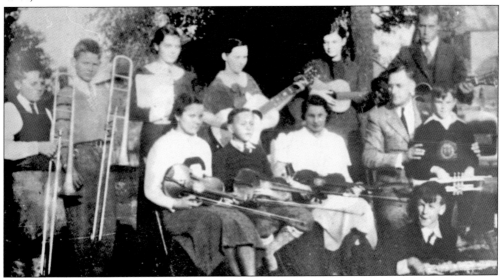

CHURCH ORCHESTRA. The Charles Town Asbury United Methodist Church Orchestra existed from 1932 to 1934. The musicians are, from left to right, (front row) Ersell Robinson Rutherford, Gordon Rosenberger, Eunice Magaha Wheeler, director/leader Henry Littge, Abner Rissler, and Robert L. Rissler; (back row) Harvey "Tuffy" Lehman, John Mathena, Louise Marshall Pine, Doris Magaha Withrow, Hilda Marshall Kable, and Charles Moler. (Courtesy of collection of Bill Theriault, Bakerton, WV.)

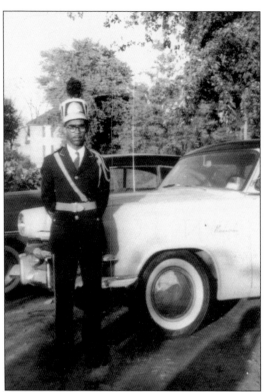

BARRY BURNS. Barry Tyler Burns poses in his Shepherd College band uniform in 1959. Barry entered Page-Jackson High in 1953 and graduated in June 1958. When he was 19 he met Ruby E. Turner, from Upperville, Virginia, at John Brown's Farm, a well-known dance hall. They were married in Hagerstown, Maryland, and settled in Virginia. Eventually they relocated to Frederick, Maryland, and had two daughters and two grandsons. (Courtesy of Ruby and Barry Burns, Frederick, MD.)

INAUGURAL OPENING. This 1978 photo shows a scene from *My Fair Lady*. Mrs. Annie Packette, a descendant of Charles Washington, wanted Jefferson County to have a center for the arts. She raised $50,000 and architect T.E. Mullett was commissioned to design it, with Hugh P. Cline as the builder. February 11, 1911 saw the first show. The stage went dark in 1948, the building condemned in 1958, restored in 1972, and reopened in 1973. (Courtesy of collection of Bill Theriault, Bakerton, WV.)

Ten

CHARLES TOWN TODAY

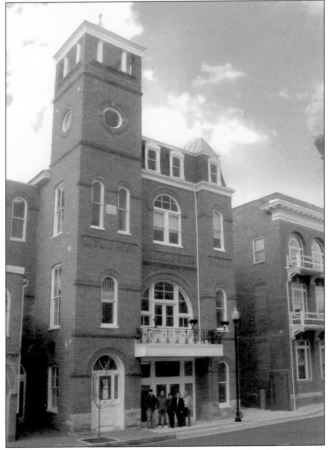

VISITORS' CENTER. These tourists are pictured in front of the Charles Town Visitor Center, on the northwest side of N. George Street between Washington and Liberty Streets. The Visitor Center is open daily. These tourists are, from left to right: Walt Wojcik from Harpers Ferry; Ray and Linda Weaver from Indiana, Pennsylvania; and Irene and Tony Romanie from Creekside, Pennsylvania. (Photo by Dolly Nasby.)

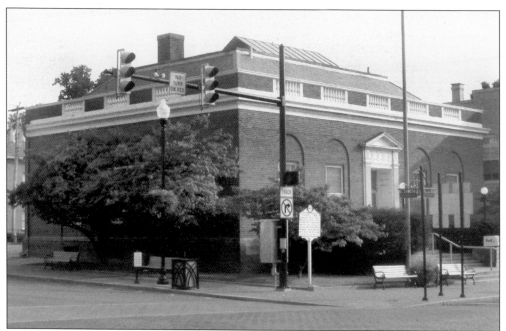

POST OFFICE. The post office is located on the site where the original jail was once located. That jail was razed in 1919 and the post office was constructed on that site. Charles Washington had wanted all four lots in the center of town to be devoted to community use. (Photo by Dolly Nasby.)

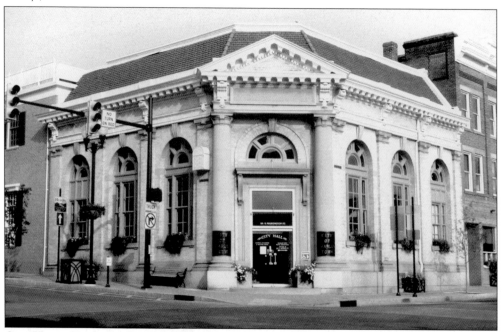

CITY HALL. City hall is located directly across the street from the Charles Town Courthouse on the southeastern corner of E. Washington Street and S. George Street. It has been beautifully maintained over the years, even displaying window boxes along both streets. Inside the city hall there are many photos of Charles Town in earlier days. (Photo by Dolly Nasby.)

JEFFERSON COUNTY MUSEUM. Pictured here are Harpers Ferry residents Matt and Judy Jones and their children, from left to right, Blake, Brooke, and Kaitlin. Among other things housed in this museum are the wagon that carried John Brown to his execution, the cot on which Brown rested during his trial, and Roger Preston Chew's Civil War uniform. (Photo by Dolly Nasby.)

OPERA HOUSE. The Opera House is located on the northwestern corner of N. George Street and E. Liberty Street. It is used throughout the year for productions put on by the local theater company. Auditions are held periodically so local talent can perform. In addition, some dance studios have their recitals there each year. (Photo by Dolly Nasby.)

LAKELAND CAVERNS ESCAPE. Pictured here is the escape hatch, so to speak, of the Lakeland Caverns. The caverns were discovered on April 13, 1906. A new livery stable was under construction on Liberty Street, and the workmen were excavating when the cave was found. A subterranean passage between two layers of rock led to a large clear lake. Visitors could visit the lake and even take boat rides. (Photo by Linda and Ray Weaver, Indiana, Pennsylvania.)

WASHINGTON GRAVES. Pictured here as some of over 70 graves of Washington family members located in the Zion Episcopal Church graveyard on Congress Street between Church and Mildred Streets. The stone wall visible in the background of this photo was built by Confederate spy John Yates Beall. Union troops were quartered in this church during the Civil War. The location of the Washington graves was identified by local resident Mr. Benny Jenkins. (Courtesy of Dolly Nasby.)

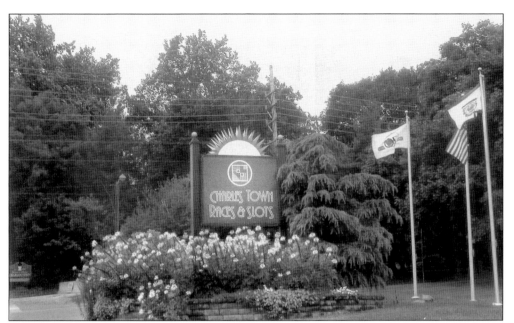

CHARLES TOWN RACES & SLOTS. There are two entrances to Charles Town Races & Slots— this one on the south side, Route 340, and another one on the north side, where there is a parking garage. Racing enthusiasts and those interested in gaming flock to Charles Town every year. Live racing is held most days of the week, and gaming is available seven days of week. Of course, hours and days are subject to change. (Photo by Dolly Nasby.)

PETER BURR HOUSE. The Peter Burr House, located on Route 9 off East Burr Boulevard, is one of the oldest frame structures in West Virginia. It was built in 1751 by Peter Burr for his son. Peter Burr was first cousin to Vice President Aaron Burr. Pictured here are Henry and Barbara Lynn from Berkeley Springs standing beside Wanda Pyles, volunteer and master gardener from Martinsburg. Local residents are raising funds to restore the property. (Photo by Dolly Nasby.)

BIBLIOGRAPHY

Bushong, Millard Kessler. *Historic Jefferson County.* Boyce, Virginia: Carr Publishing Company, 1972.

Jefferson County Bicentennial Committee. *A Bicentennial History, Jefferson County, West Virginia, 1801–2001.* Martinsburg, West Virginia: Quebecor Printing, 2002.

Jefferson County Black History Preservation Society. *A Collection of Black History Events in Jefferson County, West Virginia.* Volume I: 1700–2001. Charles Town, West Virginia: Jefferson County Black History Preservation Society, 2001.

Jefferson County Black History Preservation Society. *Souvenir Calendar of Black History in Jefferson County.* Charles Town, West Virginia: Jefferson County Bicentennial Commission, 2002.

Jefferson County Historical Society. *Between the Shenandoah and the Potomac: Historic Homes of Jefferson County, West Virginia.* Winchester, Virginia: Winchester Printers, Inc. 1990.

Jefferson County Black History Preservation Society. *The Capture, Trial, and Execution of John A. Copeland Jr. and Shields Green.* Charles Town, West Virginia: Jefferson County Black History Preservation Society, 2003.

Oates, Stephen B. *To Purge This Land With Blood.* Amherst: UMASS Press, 1984.

Sears, Roebuck and Company. *1908 Catalogue No. 117.* Chicago: The Gun Digest Company, 1969.

Taylor, Evelyn M.E. *Historical Digest of Jefferson County, West Virginia's African American Congregations 1859–1994.* Washington, D.C.: Middle Atlantic Regional Press, 1994.

Taylor, James L. *A History of Black Education in Jefferson County, West Virginia 1865–1966.* Shepherdstown, WV: National Conservation Training Center, 2003.

————. *Africans-in-America of the Lower Shenandoah Valley: 1700–1900.* Charles Town, West Virginia: James L. Taylor, 2001.

Theriault, William D. "For Love and Money: Jefferson County Horse Racing." *Goldenseal: West Virginia Traditional Life,* Spring 1989.

————. *Explorer: The West Virginia Division of Culture and History.* CD-ROM. Charleston, WV: West Virginia Division of Culture and History, 1996.

The Statistical History of the United Stated from Colonial Times to the Present. Stamford, Connecticut: Fairfield Publishers, 1962.

U.S. Department of the Interior. *John Brown's Raid.* Washington, D.C.: Office of Publications, National Park Service, 1974.